EVESHAM
TO BREDON
From Old Photographs

I would like to dedicate this book to my wife, Elsie, in thanks for all the spadework she has put into its preparation.

EVESHAM
TO BREDON
From Old Photographs

FRED ARCHER

AMBERLEY

First published by Alan Sutton Publishing Limited, 1988
This edition published 2009

Copyright © The Fred Archer Trust 2009

Amberley Publishing
Cirencester Road, Chalford,
Stroud, Gloucestershire, GL6 8PE

British Library Cataloguing in Publication Data.
A catalogue record for this book is available from the British Library.

ISBN 978-1-84868-438-6

Typesetting and origination by Amberley Publishing
Printed in Great Britain

CONTENTS

INTRODUCTION

I have tried to portray in my collection of photographs something of the life and social history of Bredon Hill villages and the Vale of Evesham – a part of England so aptly described by John Moore as 'England's Middle West'. If only I had realised 60 years ago how vital it was to capture the village scene, so many more people and events would have been in black and white.

Old friends have lent me their prints to reproduce. The faces of some of them speak to me much more than the written word.

Charles Spires of Grafton, born in 1812. I never knew him but his grandson, Bill, worked for us on the farm. Bill was a stockman. He is shown holding our Hereford bull, Joker, in the bull yard. Our bull served the cows of the village and around and brought in 7s. 6d. each service. Bill Spires lived to see the introduction of artificial insemination. He was dubious of the new practice and his verdict was that the 'cow didn't enjoy it very much'. It is so easy to map events today in colour but I maintain that the photos in black and white sometimes say more. The problem of the photographers in our grandparents' day was that the subject had to stay still for a time exposure. Photos in sepia of Grandad standing with his hand on Grandma's shoulder are common. Taking a photo in this way kept the subject perfectly still.

I have tried to include as many prints as I could of folk working. John Crump with his team of horses coming along Lenchwick Lane at Grafton is a good example.

The picture of Grandad and Grandma with my Dad and their donkey cart was taken in the 1890s. Grandad was born in 1827 during the reign of George IV. He was prosecuted for letting his donkey, Neddy, stray on the highway. Dad went to Winchcombe Court to answer the summons for Grandad, where he was fined 1s., plus 4s. costs. You will notice in my collection of photographs a number on haymaking, because as a boy I thought haymaking was the best part of the year. The smell of new-mown hay is beyond compare. The saying is: 'Good hay hath no fellow'.

There is so much social history in this collection, history made by folk laid to rest in the churchyard. Men who could hardly read or write but who could build a hayrick, mow a field, plough, harrow, lay a hedge, calve a cow: all for anything from 10s. to £1 for a week of 52 hours.

The women of the village picked peas, strawberries and made a few shillings in the autumn picking the blackberries on the hill. These women washed the family clothes with Sunlight Soap; there were no detergents, no tumble driers, but the white sheets, shirts, etc., were brilliant on the line, like the sails of a ship.

I rather like the picture of Beckford Fire Brigade of more than a hundred years ago.

They stopped in Rabbit Lane on their way to a fire at Ashton to have their photos taken by Trotting Johnny, an early photographer from Alderton. It is recorded in the parish magazine that it was that local fire engine which saved Nathan Burges' house. It stated that the horses had to be caught on Tewkesbury Ham to bring the Tewkesbury engine to Beckford two hours later.

You may well ask where the collection of photographs came from. The majority are from my own collection. When I visited country folk in their cottages and saw an old photograph and liked it, they would lend it me to get a reprint. Lots of the other prints are from the family album. I have borrowed some from Evesham Almonry Museum and a few from Woodstock Museum. Mrs Norah Gay, who now lives near Chard in Somerset, lived and farmed at Tythe Farm, Gretton, near Winchcombe. Her name then was Miss Russell. Her father was a well-known breeder of Shorthorn cattle at the turn of the last century. The late Mr Knight who used to live at Bredons Norton let me have a few interesting pictures.

The photo of Dr Roberson at the village cross in Ashton under Hill gives one an insight into the man and the age he lived in. Village folk on the cross are sitting around while he sits majestically in his trap with Lavender, his faithful horse, in the shafts. Definitely a father figure was the Doctor.

George Hunting, the reigning sprout-picking champion, takes you to the sprout field in Crashmore Lane at Overbury. George stands there proudly holding the silver cup he won at the Championship Meeting near Cropthorne. Dad stands on one side and Mr Cartwright from Harveys of Kidderminster on the other side. He sold the fertilizer to grow the sprouts.

A ten-hogshead barrel with the cider-makers was taken at Hampton, near Evesham, when Birds were cider-making. It has been said that when Birds were cider-making the River Avon went down a foot in depth. Not true, of course. The local cider was potent stuff, known of late as Rocket Fuel.

You will see pictures of what were called Black Horses, steam engines ploughing, threshing, etc. One belonging to Squire Baldwyn is sawing timber. A deadly circular saw without a guard to protect the sawyer from the blade. Early farm mechanisation had many casualties, including the sawyer in the picture, Mr Jonathan Baylis.

What a change there has been in the Vale villages since men like Mr Baylis of Littleton, seen digging his land, were working their holdings. Men like him dug and cut their 'gras' (asparagus), grew strawberries and wallflowers, and worked from daylight until dark. The land today is farmed and gardened in big units. Production is higher, but the land was never so well cared for as when the Evesham market gardeners made a living from six acres.

When you study the photograph of the four-horse team ploughing it is a lovely country scene, but what is known today as time-consuming and labour-intensive. Ralph Pratt and I used to plough three-quarters of an acre a day with four horses. It took 15 days to plough the 10 acres in the Pike Ground. A tractor today would plough it in less than a day.

This collection of pictures represents the end of the horse age on the farm. The sight of the ploughman and his team is a pleasant memory now only to be seen at ploughing matches.

> I've seen on a dusty headland
> All Babylon's Host and more
> When a boy on a jingling plough horse
> Rode home like a conqueror.

Photos of the football and cricket teams are included. These were a vital part of village life. Also the church and chapel and the village pub, places where village politics were mulled over. Going to chapel on winter nights I've seen villagers walk up the road when there was no moon carrying candle lanterns.

Among the photographs is one of Mr Frank Court with a number of rabbits hocked and paunched on a stick. This was the usual way to carry the bag after shooting on Bredon Hill. Mr Court used to live in Ashton under Hill. A picture of a little group with ferrets is one so common in the past before the rabbits were almost made extinct by myxomatosis. My cousins Tom and Fred Griffin killed 6,000 rabbits one season on Bredon Hill in the 1920s.

Photos in my collection vary from those of the high and mighty to pea-pickers and men who lived a life lying rough in barns and stables. The Duke of Aumale, fourth son of the deposed King Louis Philippe of France, was followed as Squire of Wood Norton by his nephew, the Duke of Orleans. This is a photo of a handsome man who turned the hearts of Worcestershire ladies. Tetbury Ted in his smock coat riding a cart horse outside the Plough and Harrow pub is at the other end of the scale. He lived in an outbuilding at Holloway Farm, Ashton under Hill, doing boy's jobs on the farm, fetching and carrying. One of his tasks was to take jars of cider to the haymakers riding a cart horse.

Regarding the houses and cottages pictured in the book one thing needs to be said: times have changed dramatically these last 60 years. The picturesque cottages were rented to farm workers at 3s. a week with no rates to be paid by the occupier, the landlord paying these very low amounts. Men on 30s. a week were poor, 3s. being a tenth of their wages. The same cottages are today occupied by the better-off. They are worth, on the market, anything between £50,000 and £100,000. We don't have to look very far to see a revolution. Cottages built and occupied for 300 years by the workers on the farm are now worth their weight in gold. Some may question why the old stables and cow sheds are now cottages and bungalows. Any farm building today where there is no room for a tractor to work to clean out manure or store grain is useless for farming practices. It would be a pity if some at least of the characters, events and places went unremembered.

This is my selection. I do hope you like it.

Fred Archer
1988

SECTION ONE

Working on the Land

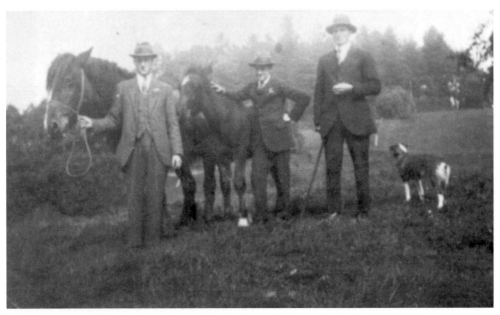

WILLIAM KNIGHT of Bredons Norton with two of his horses. Mr Knight is on the right of the picture. 1920.

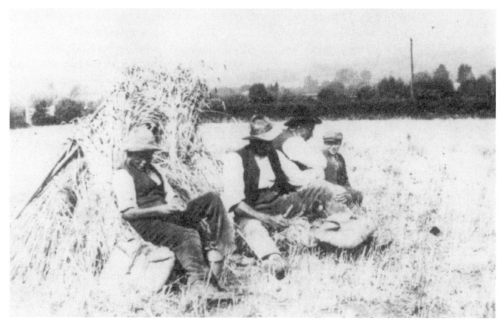

BAIT TIME ON JOHN CRUMPS FARM AT GRAFTON. The Spires family sitting under a stook dressed in cords with wideawake hats. Their frail baskets are by their sides and the cider jar is not far away. *c*.1900.

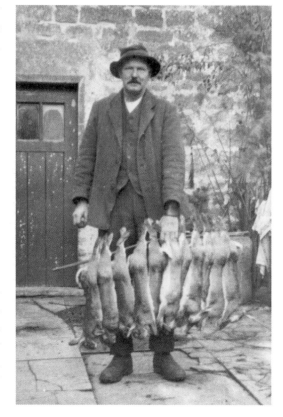

FRANK COURT, who lived at Ashton under Hill before the First World War, seen here with a stick of rabbits taken on Bredon Hill. Frank was a baker. His father married the daughter of John Baldwyn being a well-known family dating back 6 centuries.

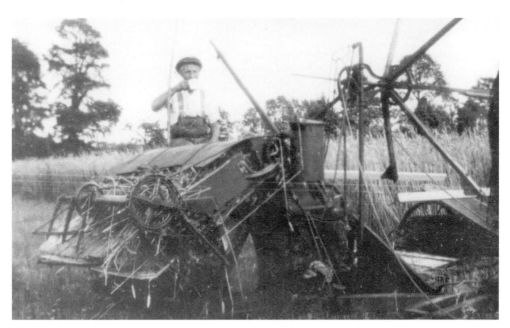

JACK RANDALL having a drink on the binder during wheat cutting for J. C. Nicklin & Son at Ashton under Hill, in the 1920s. Jack was the firm's carter for many years. His brother Fred worked for my father. He was Chapel, played the melodion and was milder man than jack.

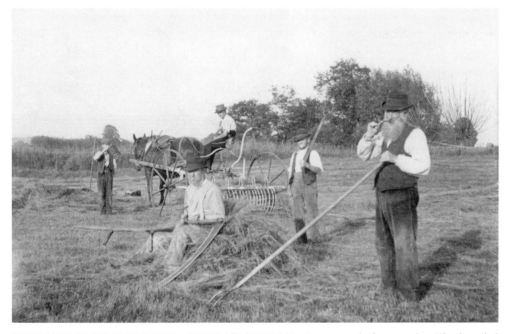

HAYMAKING BY THE RIVER AVON AT BREDON. A very early horse rake. The bearded man has a long pitchfork or 'shuppick'. The man on the haycock seems proud of his scythe. Early twentieth century.

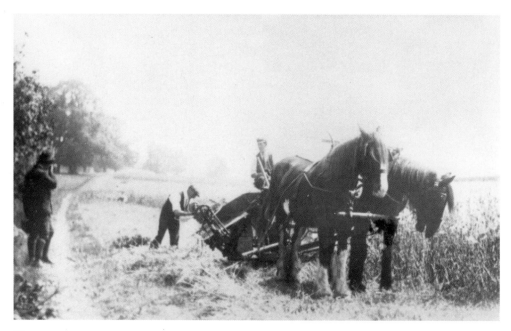

TWO HORSES ON A BINDER. The man on the ground is having trouble with the part that ejects sheaves. The man on the left with the gun is aiming at a rabbit. Bredon, 1920.

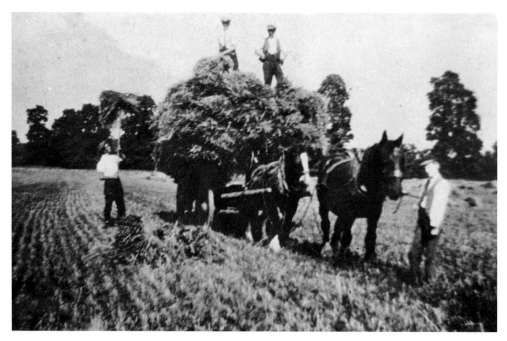

TURPIN AND BLACKBIRD PULLING THE WAGON. George Hunting is pitching the sheaves. Jack Barnett and Walt Sallis are loading, with me, Fred Archer, leading Turpin in the Thurness Field at Ashton under Hill.

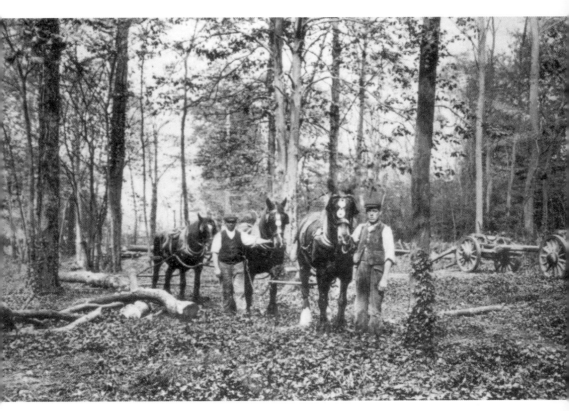

TIMBER-HAULING IN ASHTON WOOD. 1916.

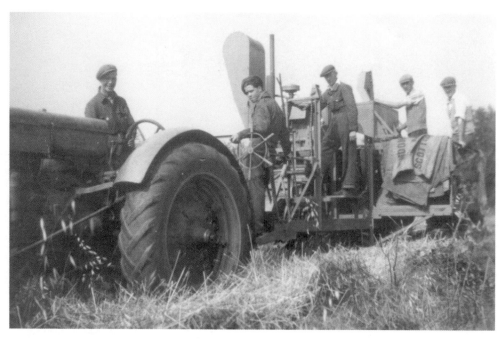

THE FIRST COMBINE HARVESTER ON MY FARM, a Minniapolis Moline, with George Warren from Dumbleton. I am on the machine with Roy Pratt. 1952.

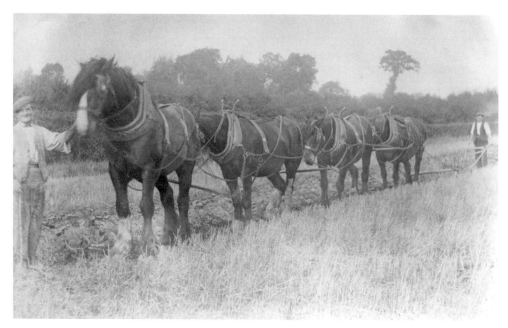

PLOUGHING WITH A FOUR-HORSE TEAM on Wilderness Farm, Alderton, 1920. The horses, starting from the front were: the Foremost, the Body Horse, the Lash Horse and the Filler.

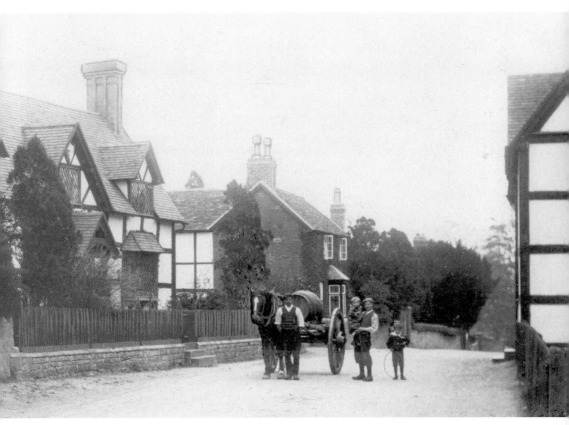

WATER-CARTING at Bricklehampton near Pershore, 1925.

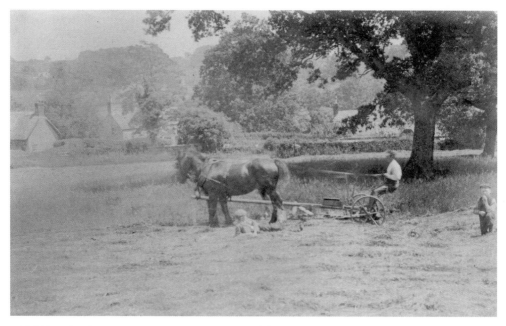

MOWING IN OVERBURY PARK. Pre-First World War.

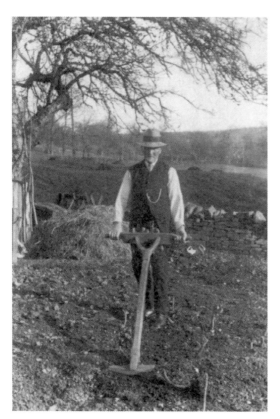

BREAST PLOUGHING AT OVERBURY, 1909. Breast ploughs were used on allotments to skim over the land before planting. The ploughman pushed the plough with his thighs.

16

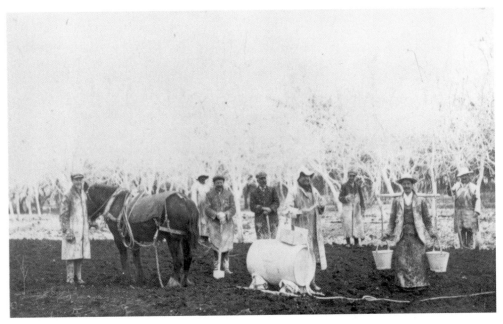

SPRAYING FRUIT-TREES with Lime Sulphur at Pinvin, 1919, on W. J. Gardiner's holding.

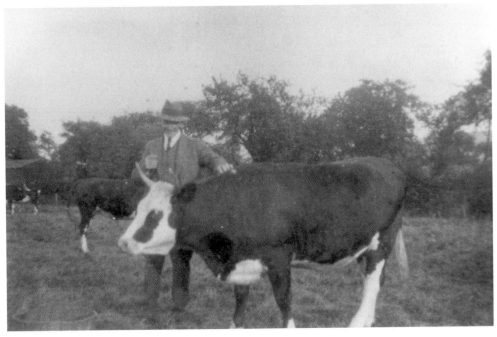

DAD WITH A HALF-BRED HEREFORD HEIFER at Stanley Farm, 1925.

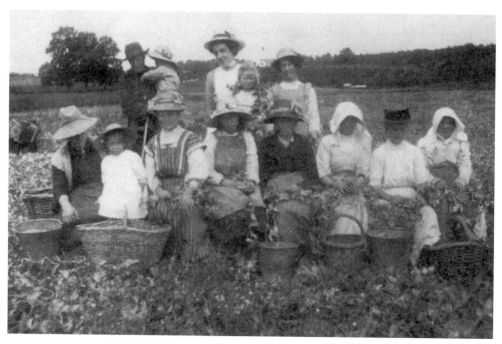

PEA-PICKING on Dad's land at Grafton. 1907.

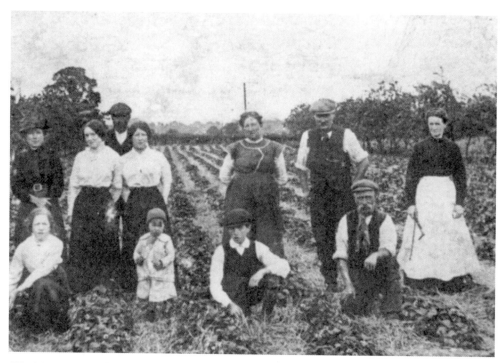

STRAWBERRY PICKING on Dad's land at Grafton *c*.1907. Note the white blouses of the two women and the white apron of the other.

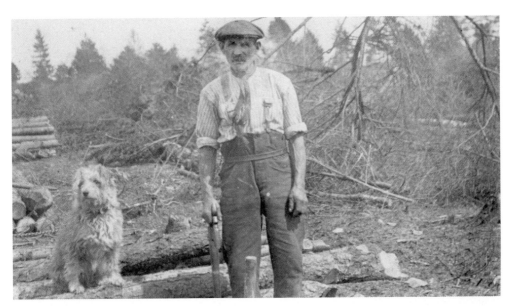

JACK HUNTING of Ashton under Hill making pit props on Bredon Hill during the First World War. By his side his dog, Rough. Jack was an expert rabbit-catcher, catching thousands of rabbits on Bredon Hill with the long net and with snares. He always started drinking at Star Inn with a quart of cider – a pint was no use to him!

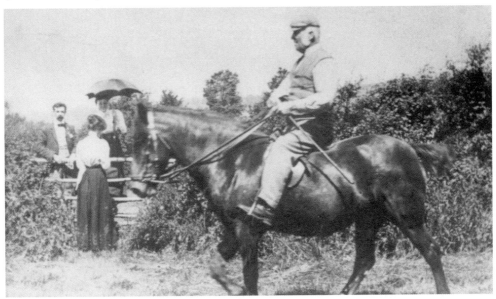

JOHN CRUMP of Grafton riding around his farm with long stirrups, cavalry fashion. Bunch Baldwyn is the lady by the stile. She was his housekeeper and looked after students on the farm; a kind, eccentric lady who was terrified of thunder. She would say to our cowman: 'It's a nice day, Tom', and he would reply: 'I think we shall have tempest tonight.' It was then that my sister had to stay the night with her under the stairs in case it did thunder.

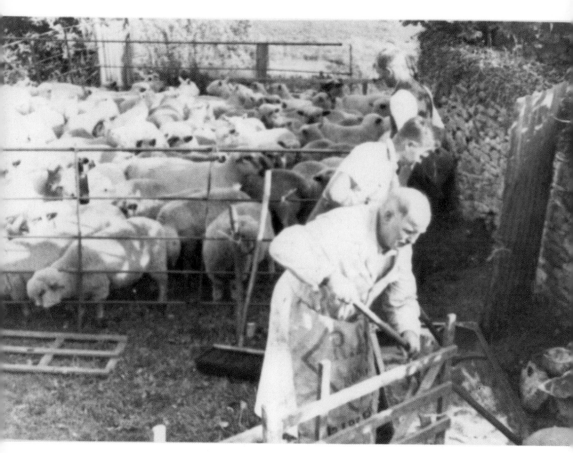

FRANK COURT dipping his Downland flock. He moved to ford on the Cotswolds in 1920.

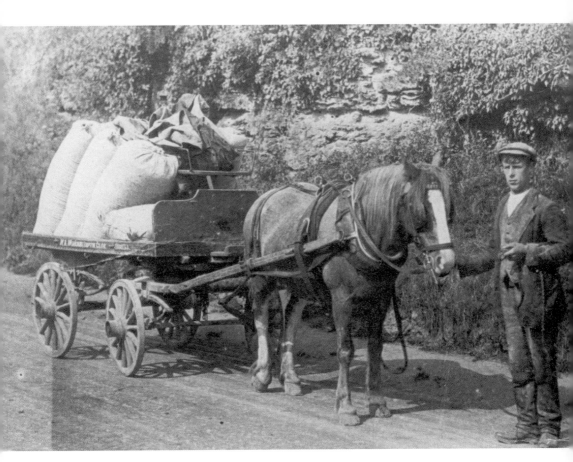

TAKING CORN TO GRIND AT SEDGEBERROW MILL, 1924. Note the spring dray. This four-wheeled dray superseded the gardener's spring cart. They were made by Goodhalls of Evesham and used extensively by market gardeners until the Second World War.

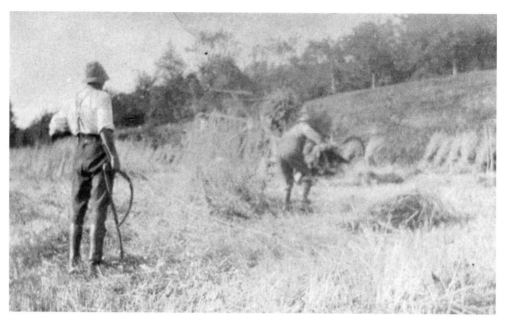

BY HOOK AND CROOK. Harvesting the old way at Bredon Norton, 1907. Note the laid crop and the long stubble.

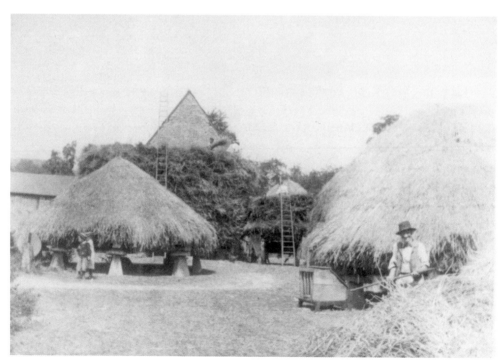

RICKS ON STADDLE STONES, Grafton, *c.*1890. Charles Spires, seen here with his pitchfork in hand, was born in 1812. Ricks built in this fashion are safe from rats and mice.

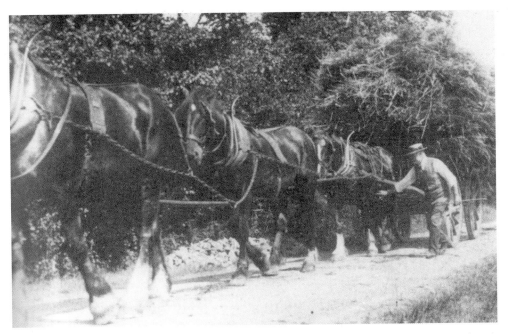

JOHN CRUMP OF GRAFTON with a three-horse team bringing a load of corn up Lenchwick Lane, early 1900s. Note his boater hat and the sleekness of the horses.

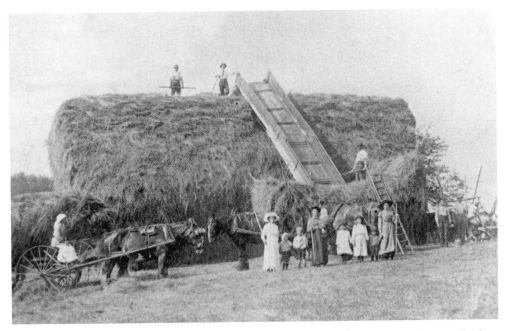

BUILDING A GREAT HAY-RICK WITH AN ELEVATOR on the river meadows at Bredon, 1900. The lady on the horse rake is not really suitably dressed, though it looks as if the ladies are helping with the hay harvest.

JOSEPH SPIRES with a cleaver, splitting withies for use as fencing, at Ashton under Hill. Joe was a well-sinker who worked with primitive windlass. He had been an engine-driver on the London and North Eastern Railway.

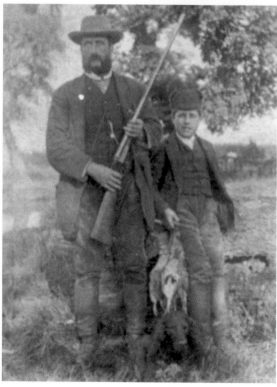

MR KNIGHT of Bredons Norton with his gun and pheasants and a small boy. Mr Knight was a good shot. He lived at Leigh Sinton near Worcester after he left Bredons

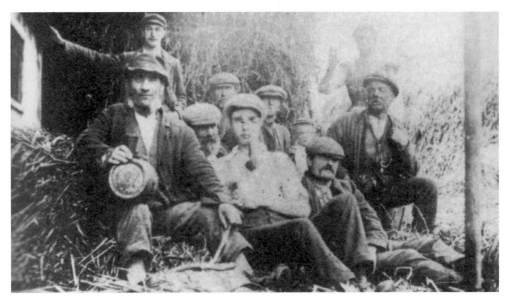

A BREAK FROM HAYMAKING with Tom Randall holding the costrel barrel of cider and my Uncle Charlie on the right with the dark moustache. It appears that the men will not be making any more hay today!

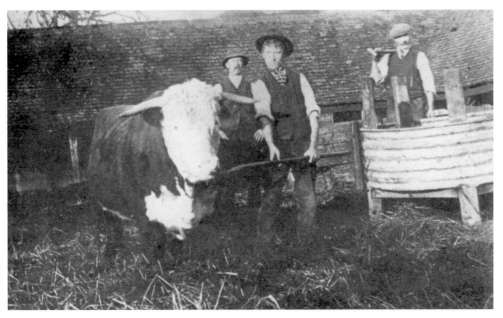

BILL SPIRES of Grafton holding Joker the Hereford bull in the yard at Manor Farm, Ashton under Hill. Mr Harry Bailey, Dad's partner, is standing by the cow crib. Joker was out of Grannie, a Hereford cow, by a bull from Mr E. T. Stephens of Elmley Castle. He was always slipping his chain and escaping. One night he went up the road, finishing with his nose ring stuck on some arrowhead railings outside a widow's house where he howled all night long.

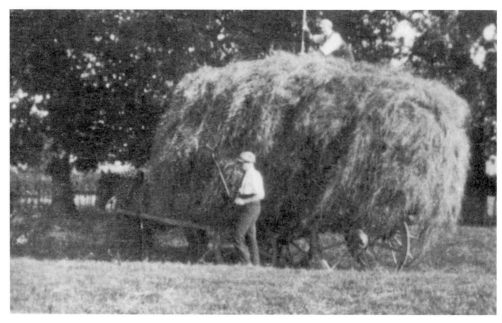

PITCHING THE HAY. Jack Randall loading from Harvey Savage, at Ashton under Hill, *c*.1920.

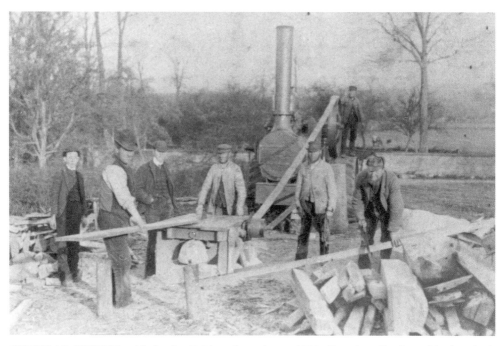

CIRCULAR SAWING with Squire Baldwyn's engine, *c*.1890. Jonathan Bayliss with the plank ,Fireman Davis on the engine. There were no guards on the saws in those days and shortly after this photo was taken Jonathan Bayliss was killed by the saw.

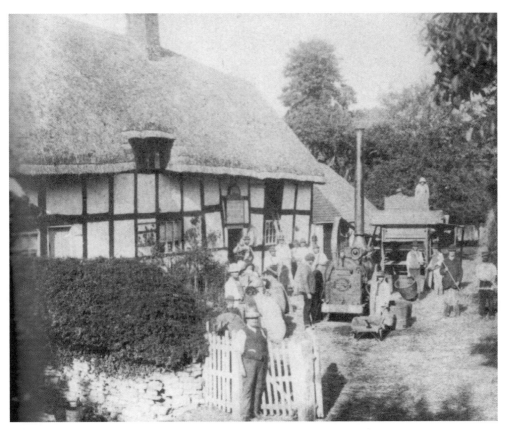

THRESHING THE ALLOTMENT RICKS in the Plough and Harrow yard. Thomas Clements, the landlord of the inn, is by the gate. Mary Barnes is on the left of the threshing machine, cutting the bands off the sheaves. The allotment-holders clubbed together at threshing time, all helping to thresh their little ricks. 1890.

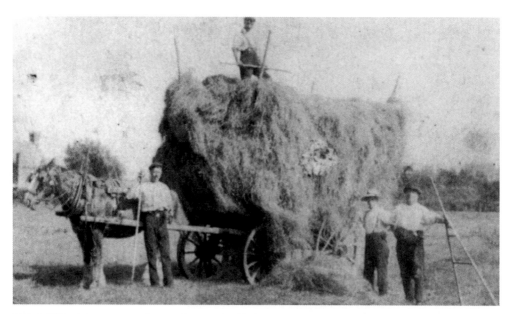

HAYMAKING, 1907. Farley Archer (Grandfather's cousin) with the heel rake, a rake used at haymaking before horse rakes were common. He was working for Albert Taylor who had a coal business at Ashton under Hill. His father owned Dumbleton Brickyard.

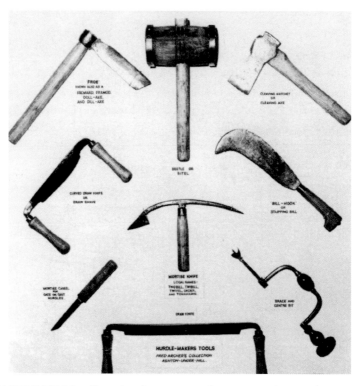

HURDLE-MAKERS' TOOL collected and given to me by Peter Matheson of Stanway in 1970.

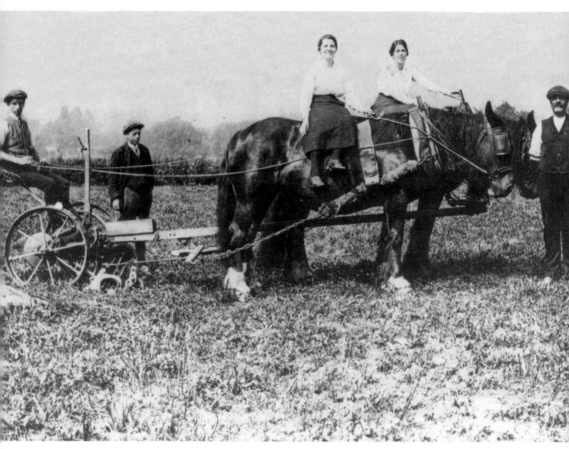

THE SPIRES FAMILY Ashton under Hill with a mowing machine. 1915, and William Richard at the horse's head. The family were small farmers at Glebe Farm. They also undertook contract work on the roads for the Council, with the horses pulling carts of stone and water-carts for the MacAdam system of road-making.

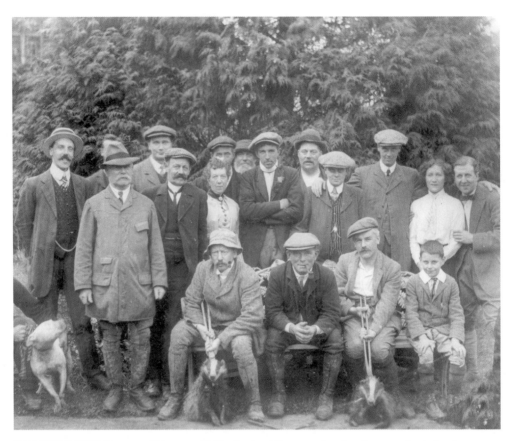

BADGER-BAITING near Alderton, 1918. Squire Gist, another local eccentric, is in the centre holding a badger with tongs. The Staffordshire bull terrier on the left is waiting to fight the badger in a walled yard. A terribly cruel so-called sport.

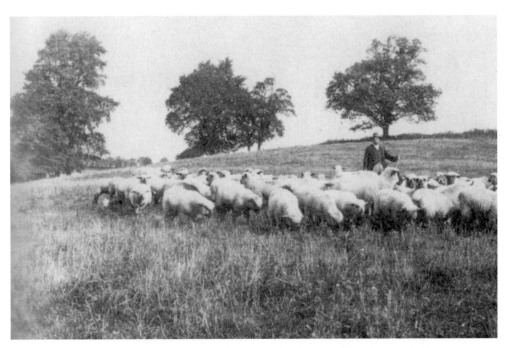

SHPERHERD TIDMARSH with a flock of our ewes on Bredon Hill, *c.*1925.

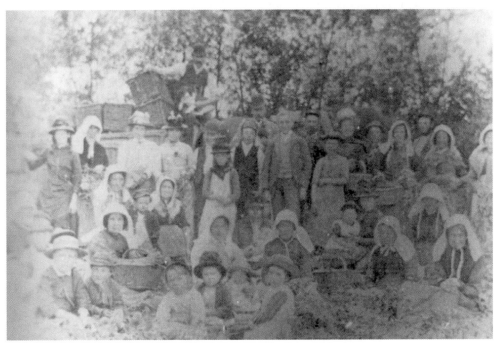

MR SAM COPE'S PEA-PICKERS at Ayles Acre, Ashton under Hill, in 1909. Sam Cope sen. is at the back with a bowler hat. He was the first man to grow asparagus commercially in Ashton under Hill.

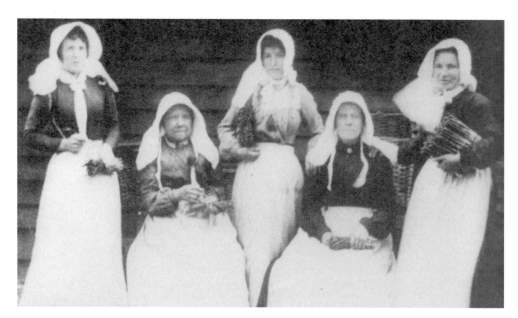

ASPARAGUS-TIERS at Hinton the Green, 1890. Eliza Cotton, Mrs Barnes and Ethel Whittle are in the centre. The women tied, with raffia, 30 buds of asparagus, known as 'gras', after it had been cut by the men. The men made large bundles of 120 buds tied with withies.

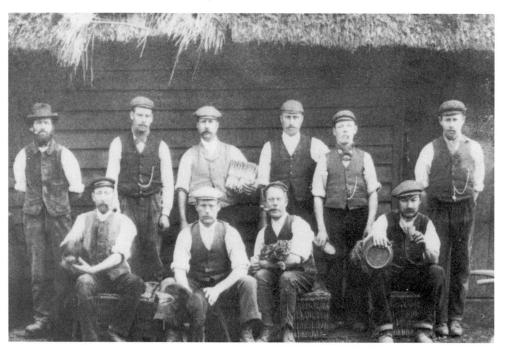

APSARAGUS-CUTTERS at Hinton on the Green, 1890. The worked at Ballards Farm for Mr Jim Marshall. The buds were cut with special asparagus knives. Note the costrel barrel of cider!

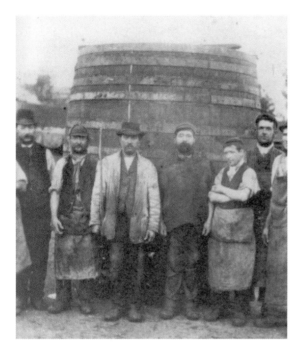

CIDER-MAKERS in front of a ten-hogshead barrel. A hogshead can be anything from 60 gallons to 120 gallons . . . a very big barrel! Picture taken at Mr Bird's yard at Hampton near Evesham. The man on the extreme right is Mr Brooks from Sedgeberrow, He had a smallholding in a field called Hammer and Length at Sedgeberrow.

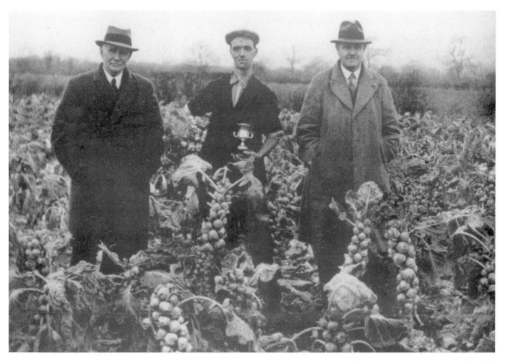

THE SPROUT-PICKING CHAMPION, Mr George Hunting, with the cup he won. On the left is my Dad, Tom Archer, and on the right is Mr Cartwright of Harveys of Kidderminster who provided the fertilizer. The picture was taken on the Overbury Estate.

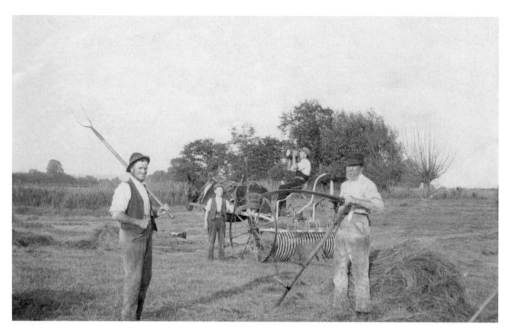

A HAYMAKING SCENE at Bredon early this century. A break while the man on the horse rake has a drink and the man on the right sharpens his scythe.

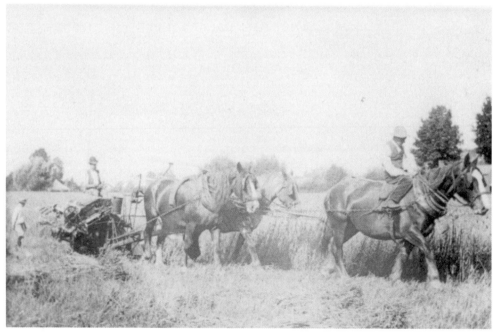

A SCENE AT GRAFTON: binding the corn with a chap riding the Foremost horse. These horses, Suffolk Punches, look a lighter breed than shire-horses. 1912.

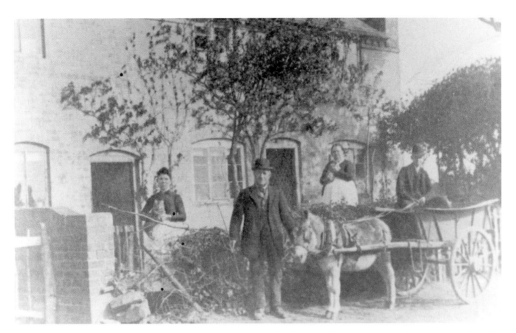

GRANDFATHER WILLIAM ARCHER with his donkey and cart outside his cottage. Dad is sitting in the cart. Grandfather use to take market garden produce to Evesham Market, a journey that took all day there and back. Grandmother is in the garden by the door on the right. This photo was taken in 1894.

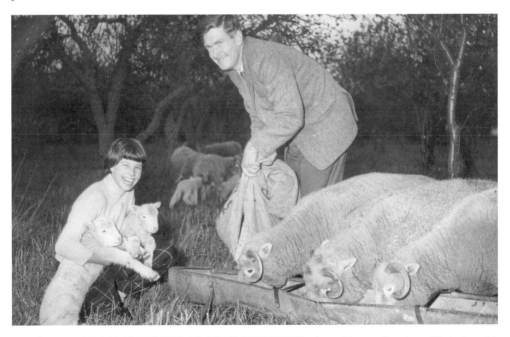

A PICTURE OF ME AND MY DORSET HORN EWES, alongside my daughter, Shelagh, with the lambs. These ewes lambed in November 1957.

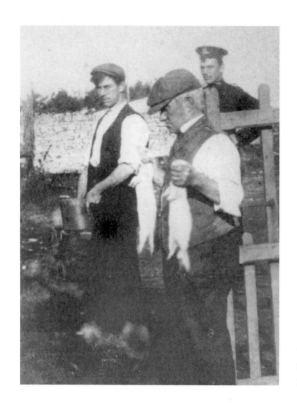

A PHOTO OF MEN WITH FERRETS going rabbiting on Bredon Hill, taken in 1928.

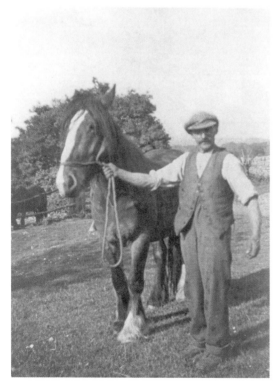

RALPH PRATT, our carter, with Blackbird a gentle horse, photographer in 1930.

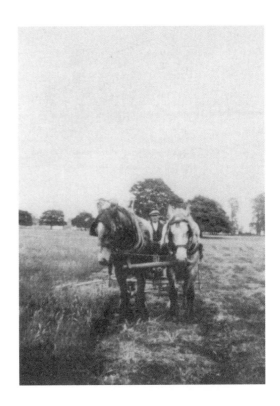

WILF GRINNEL of Ashton under Hill, mowing with a pair of horses on Overbury Estate, in 1936.

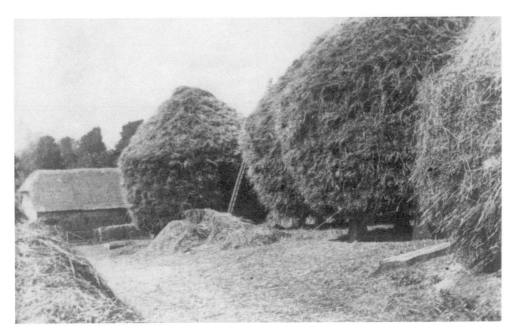

RICKS ON STADDLE STONES at Grafton. These ricks were safe from damp, rats and mice. The mushroom tops prevented the rodents gaining access to the ricks. 1920.

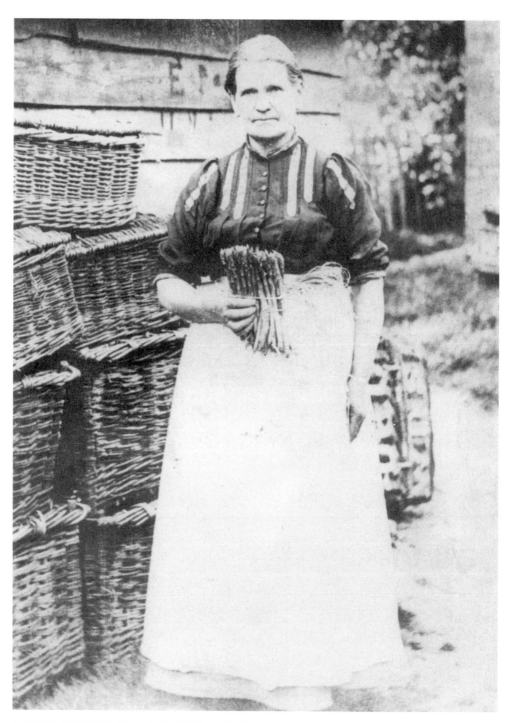

A NICE PICTURE OF A MARKET GARDENING WOMAN with a hundred asparagus, or 'gras'. The hampers in the background were used to pack the buds in for travelling by rail to London or Birmingham.

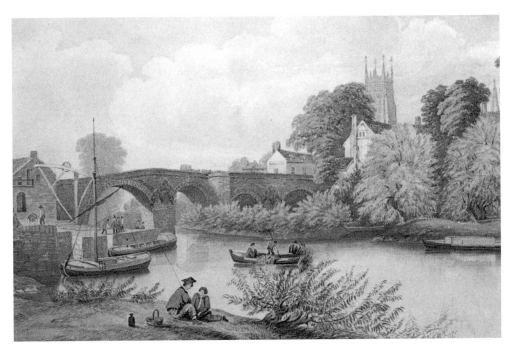

OLD RIVER BRIDGE at Evesham before the Workman Bridge was built.

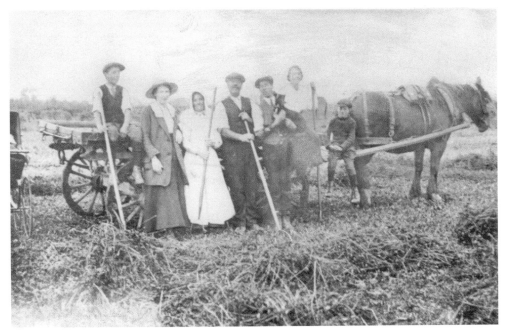

HERE IS A FAMILY READY FOR WORK. There is even a pram, and the women have their pitchforks ready. They are the Spires family from Grafton.

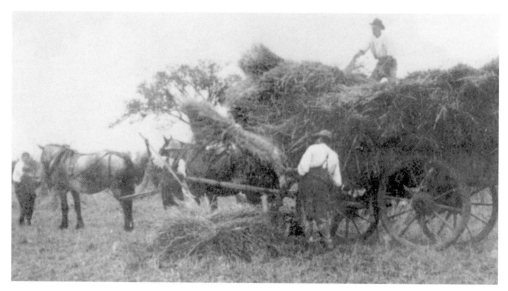

MR CRUMP'S MEN pitching and loading the oat sheaves. William Coates is on the wagon. It looks like the last load in the harvest field. 1909.

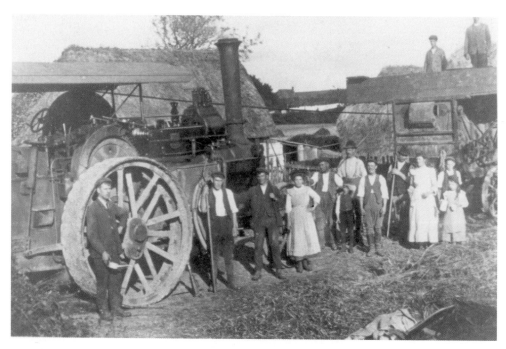

A THRESHING SCENE at Bredon Norton, 1925. There are thirteen folk around the engine and threshing machine. This may seem to be many workers but for a machine to work smoothly there would be work for at least eight folk. Others were probably there to kill the rats and mice as they escaped from the corn-rick.

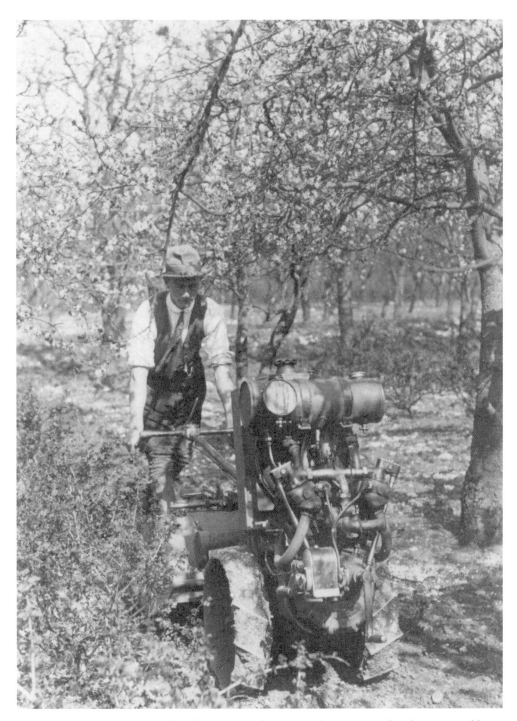

A FRUIT-GROWER working his plantation with a Howard rotavator. The plums are in bloom and there appears to be a row of gooseberry bushes on the left. This picture was taken at Harvington c.1950.

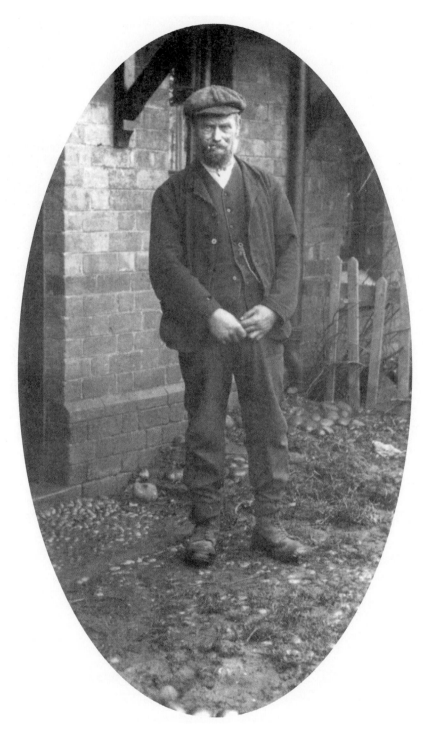

A BLACKSMITH OUTSIDE HIS COTTAGE at Evesham, *c*.1920. The man had just finished a day's work for Mr Jobson at the smith in Cowl Street.

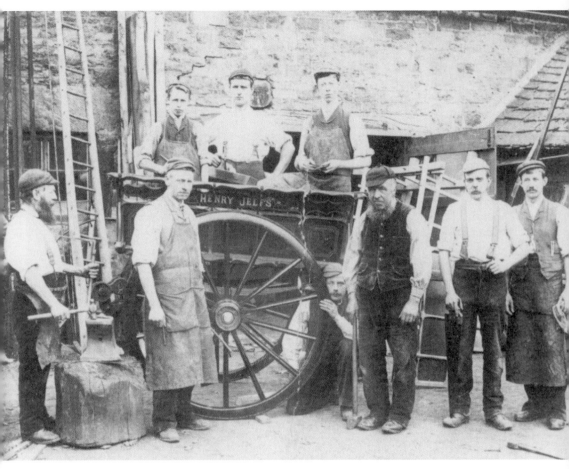

THE WHEELWRIGHT'S SHOP at Broadway, 1880. Fredrick Stokes and his father, Thomas Stokes. Jack Kyte is at the anvil, G. Roberts is the man with the beard. The Stokes were wheelwrights, undertakers and carpenters at Broadway for many years.

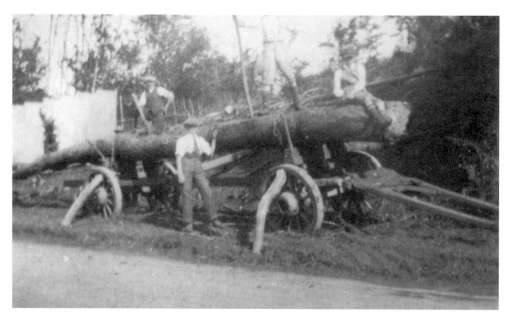

LOADING TIMBER AT WOODNORTON ESTATE. This would be between the time of the royal wedding in 1908 and when the Duke of Orleans left Woodnorton in 1912. The duke went bankrupt soon after the wedding and sold the timber in the woods and slaughtered the deer for venison.

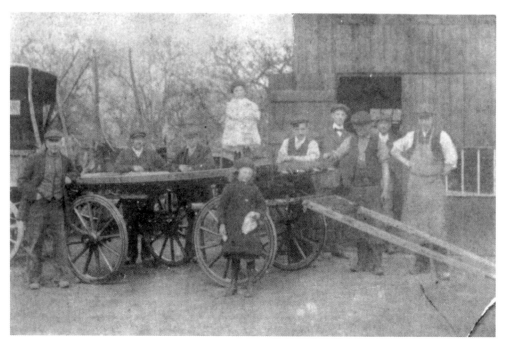

A MARKET GARDENER'S DRAY made by Stokes, 1906.

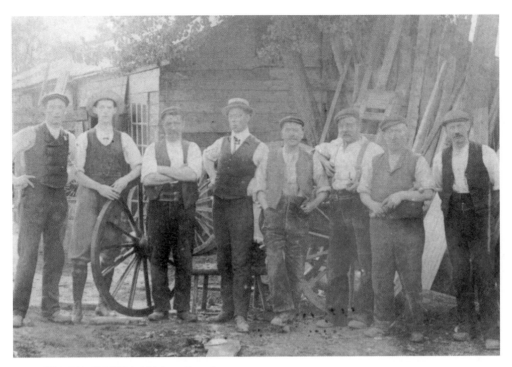

THE STOKES FAMILY, 1906, at Broadway.

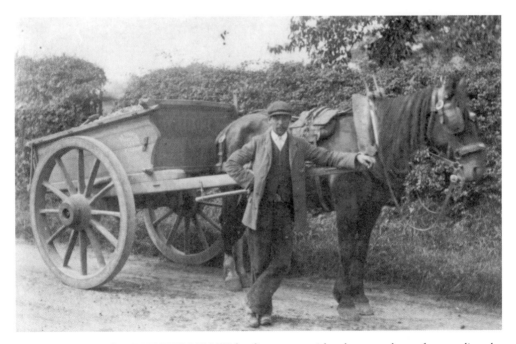

MR R. WALKER OF SHERRIFS LENCH hauling stone with a horse and cart for mending the District Council's roads. 1910.

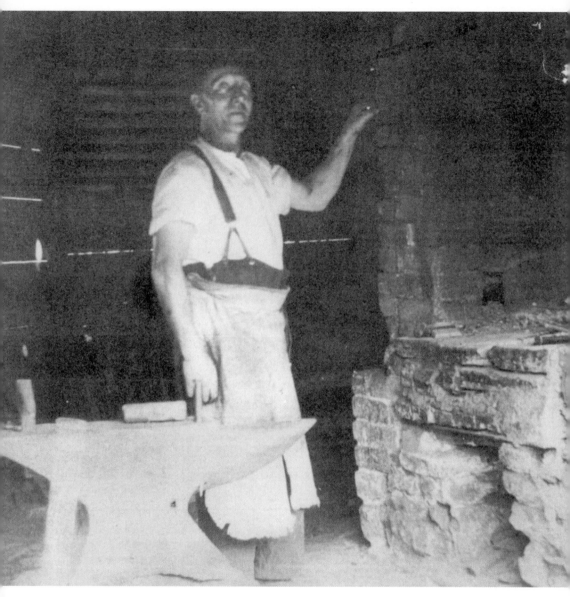

GEORGE GRIMMIT, the Harvington blacksmith, with his hand on the handle of the bellows and wearing a leather apron.

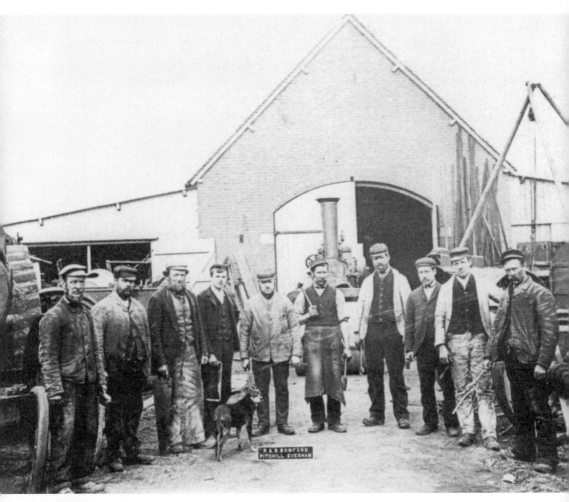

THE REPAIR SHOP OF BOMFORD BROS., Pitchill, near Salford Priors, with ten men and engines in for repair, 1900.

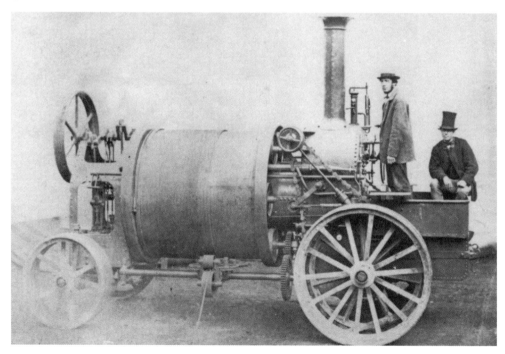

Date about 1900.

The Repair Shop, Pitchill, Evesham. (Salford Priors parish)

1. *Richard Salisbury.* *Driver of Ploughing Engine and Road Rollers also was at one time in charge of the mill at Pitchill and could dress the stones.*
2. *George Widdows.* *Driver of Ploughing Engine. (Inclined to go on the beer.)*
3. *Robert Cole.* *Wheelwright. Could make a farm wagon from the tree.*
4. *Ernest Cole.* *Son of the above.*
5. *? James.* *The Foreman.*
6. *?* *Blacksmith.*
7. *George Ludlow.* *Driver of Ploughing Engines and later foreman of Dredging gangs.*
8. *George Howard.* *Boilersmith.*
9. *Jack Brookes.* *Driver of Ploughing Engines and foreman of ploughing sets.*
10. *?* *Probably Bill Trigg driver of Fowler Road Loco and later of Steam rollers.*

EMPLOYEES OF BOMFORD BROS., Pitchill.

ONE OF TWO ENGINES MADE BY SAVERY OF GLOUCESTER for Benjamin Bomford in 1862. They were the first ploughing engines in this part of the country and were exhibited at the Royal Show, Newcastle in 1864.

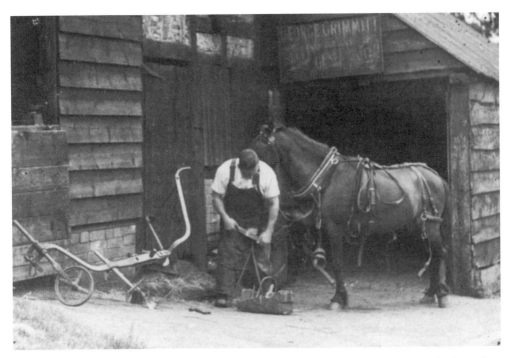

GEORGE GRIMMIT, Harvington blacksmith, shoeing a dray-horse, 1930. Note the horse hoe in for repair.

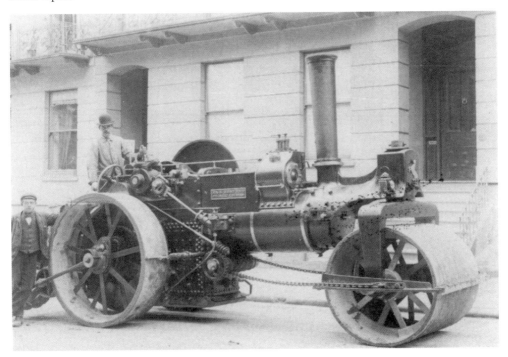

ONE OF BOMFORD BROS.' STEAM ROAD-ROLLERS, 1912.

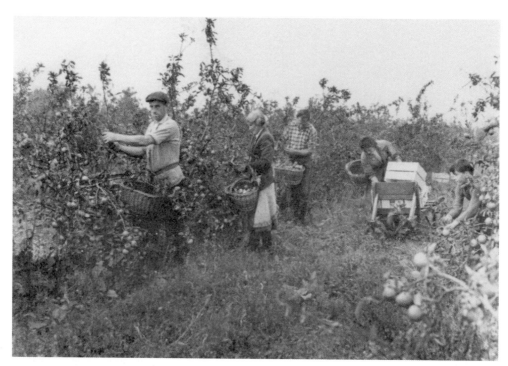

APPLE-PICKING IN THE VALE EVESHAM at some time since the Second World War. The wheelbarrow has a pneumatic tyre.

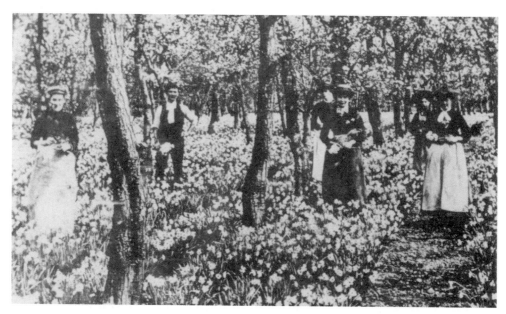

NARCISSUS-GROWING, 1900, in the Vale of Evesham, with the plum trees in blossom. A unique way of inter-cropping.

SECTION TWO

Country Characters

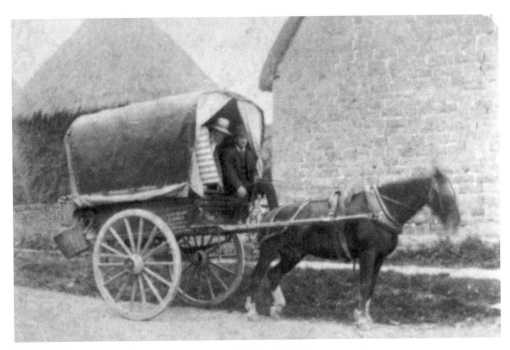

A BAKER AND HIS CART on the Cotswold Edge, 1920.

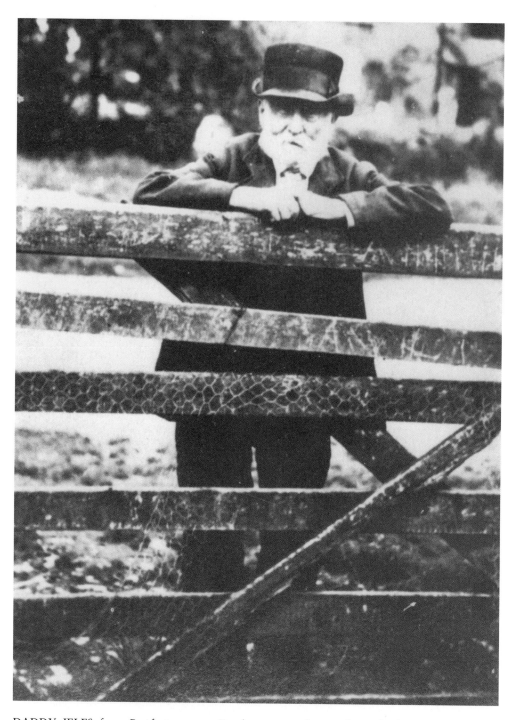

DADDY JELFS from Bretforton, near Evesham, a market gardener, looking over the gate. I wonder what he is thinking! There are so many folk called Jelfs in Bretforton that if one shouted 'Jelfs' half the village would come from their houses.

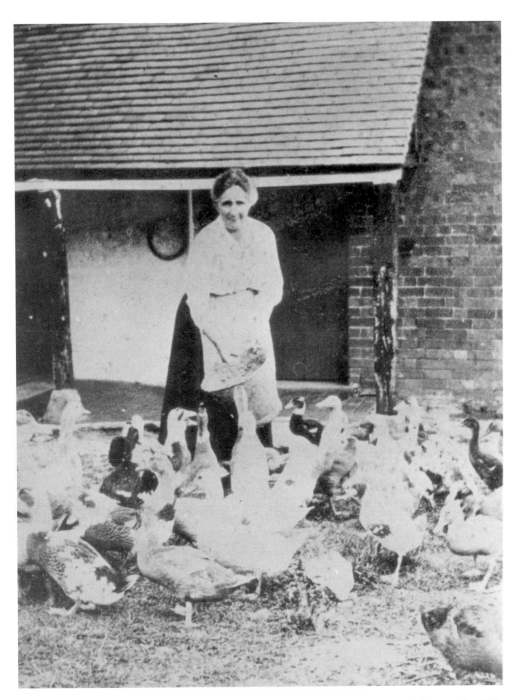

MRS HENRY BAILEY, Dad's partner's wife, feeding at Old Manor Farm, Ashton under Hill, 1918. Mrs Bailey kept her ducks in the old cider mill. In the summer Mr Bailey had to fetch them back to their quarters from some distance off the Moat Pond. Mrs Bailey sold her eggs to Fullers of Birmingham. They went in boxes by train from the station.

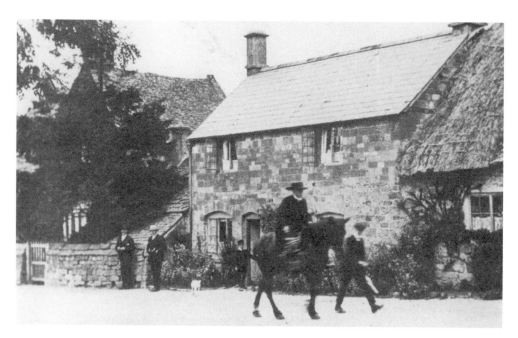

THE PARSON AT STANTON in 1910. It appears that the horse has to be lead by his man.

UNCLE GEORGE ARCHER, taken on a Sunday School outing to Weston-super-Mare, 1926. The bus is Mr Buchanan's Brown Eagle, our village bus at Ashton under Hill. Uncle George worked all his life on the land for Dad. I see he has his watch; he was very particular to be punctual and as honest as the day is long.

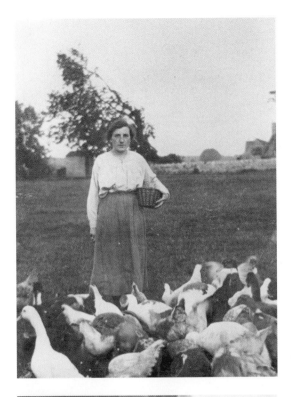

MISS MATTHEWS OF FORD, with her ducks on the Cotswolds, 1921.

TOM, OR 'STODGE', WARREN AND HIS WIFE at Sedgeberrow. Tom was our roadman. He also looked after the football field and always limped (he was lame) onto the football field at half time with a jar of cider for the players.

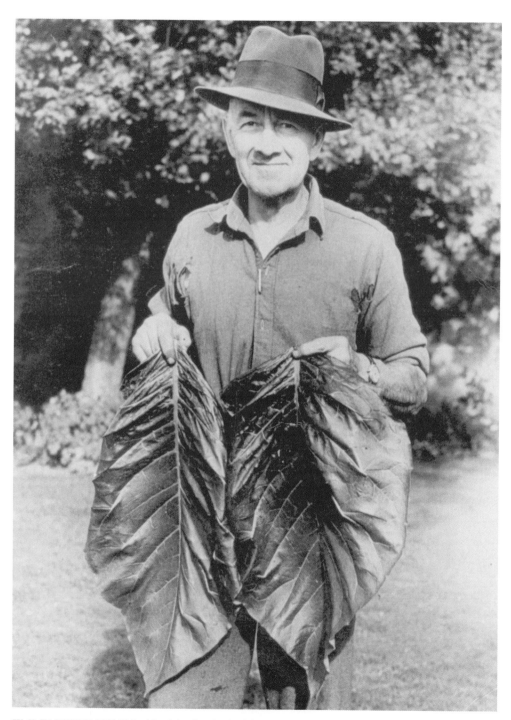

JIMMY PARDINGTON of Beckford, who had fought in the Middle East in the First World War, seen here with his home-grown tobacco leaves. A fine horseman and farmer, he won a race at Cheltenham on his horse called KBO (Keep Buggering On).

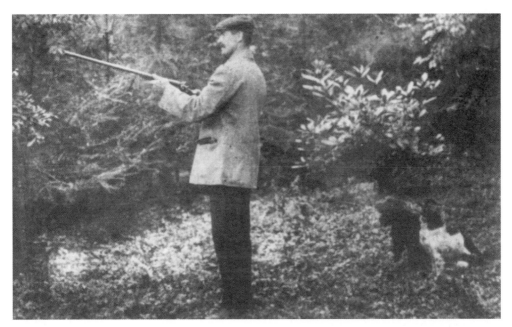

ARTHUR ARCHER, gamekeeper to J. C. Nicklin, in Ashton Wood, 1913. A fine man with a gun or axe. He fought in the First World War as a gunner in the artillery, resulting in him becoming deaf.

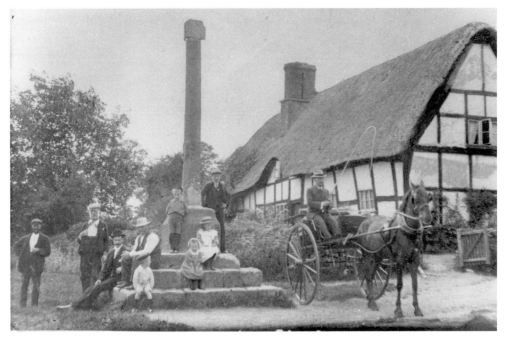

DOCTOR ROBERSON with Lavender, his horse, and trap at the Cross at Ashton, *c.*1910. Village folk on the Cross, James Cotton on the left. James was a water-diviner.

MY DAD, TOM ARCHER, born 1876. This photo was taken in 1898. He started working on the land, then at Dumbleton Brickyard. He took over 4 acres of the land from his father and finished up farming 500 acres.

MY MOTHER, photographed when she was 19 in 1898. Her name was Lily Westwood. She worked as a seamstress/lady tailor in Evesham, undertaking work for the Duchess of Orleans at Woodnorton. She lived at Port Street, Evesham, with her parents who kept a greengrocer's shop, until she married in 1913.

CHARLES MARTIN of Pershore who had land at No Gains in Bridge Street. He introduced a new variety of plum known as Martin Purple Pershore having crossed a variety known as a Blue Diamond. The special tricycle he made himself *c*.1920.

THE DUKE OF ORLEANS who lived at
Woodnorton and owned a large estate.
His Uncle came here first as a refugee
after the French Revolution as he was in
line for monarchy.

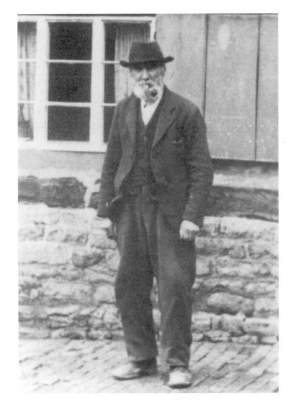

TEDDY VALE outside his cottage at
Grafton. He worked as a stone-breaker,
then on the land. He was a great man
digging with the Evesham Two Tine
Fork. He could dig a chain (or 484
square yards) in a day. When, as an old
man, he married a servant girl the vicar
asked: 'Wilt thou have this women to
be your wedded wife?', Teddy replied:
'That's what we be come yer for, unt it?'

JIM VALE, the coalman, outside his cottage, sitting on the stone cover of the standpipe from where he fetched his water. Jim, a native of Ashton under Hill, lived to be 90. He and his wife were extremely careful. His lunch was usually pastry lard. When I said to him in 1947, after the hard winter, that the weather had been severe he replied: 'Not like 1898 when we had 16 weeks of frost in February.'

CONNIE AND KATH BAILEY at the back of the bull pen at Old Manor Farm, where they lived with Mr Harry Bailey, Dad's partner, and his wife. 1917.

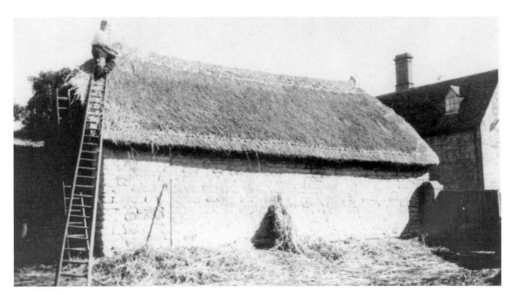

TOM BARNETT thatching. A great character and a fine singer in concerts, he served in the First World War. He was also pretty useful with his fists – not a man to argue with. Like so many he liked his cider and fat bacon from his cottage pig. 1950.

CUSTOMERS SITTING BY THE FIRE at the Fleece Inn at Bretforton. This inn was the property of the Bird family for 400 years. The last licencee was Lola Tapin, a descendant of the Birds. It is now owned by the National Trust.

> Musing sat I on the settle
> By the firelight's cheerful blaze,
> Listening to the busy kettle,
> Humming long forgotten lays.

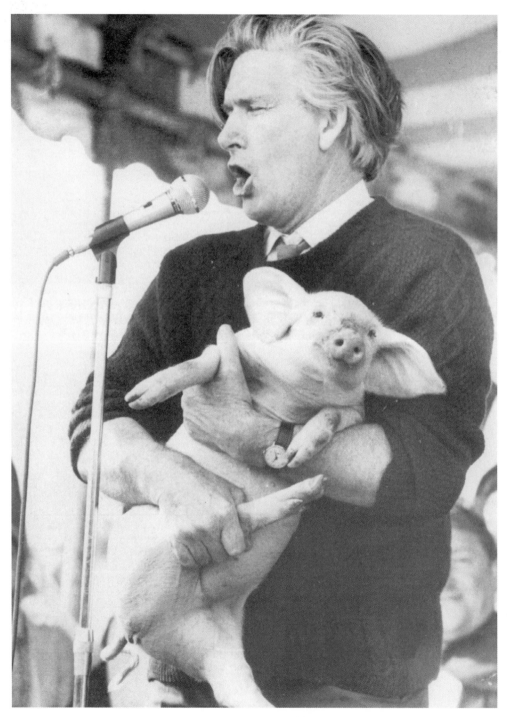

FRED ARCHER SINGING WITH A PIG at Pershore Celebrations. Something I revived from the past in which the singer won the pig if he or she didn't laugh when all about *were* laughing. 1960.

SHEPHERD TIDMARSH with his dog Rosie at Ashton under Hill. He was our shepherd from 1915 to 1938. Note his Yorks, straps below the knee, on his trousers. He was handy man with sheep and in the hayfield where he built ricks. At concerts he used to sing a song called 'The Fox and the Hare.'

MR AND MRS HARRY BAILEY with Connie and Kath outside their front garden gate, c.1920.

DAD WITH MY SISTER CLARICE AND ME on holiday, 1938.

TWO MEN OF GRAFTON, *c.*1880. Charles Spires in the dark suit on the right was the grandfather of Bill Spires (pictured on p.25).

THE BALDWYN FAMILY at the Croft, Ashton under Hill. They were the Squires of Ashton under Hill. 1911.

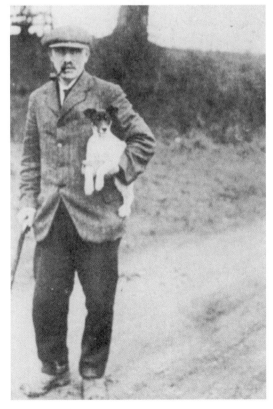

PERCY ATTWOOD of Conderton. He farmed at Ashton under Hill at Wynch farm. In his youth he played with the Fosters, Worcestershire county players, and kept wicket for Overbury. 1915.

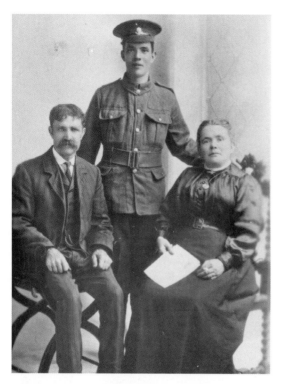

TOM HUNTING, my cousin, home on leave from France during the First World War with my Aunt Lucy and Uncle Charlie. Tom was a market gardener, well known for his strawberries, and also an excellent shot at rabbits on the run. 1916.

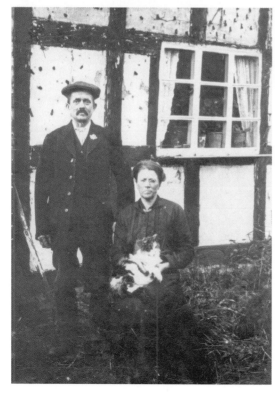

UNCLE GEORGE AND AUNT ANNIE outside their cottage, c.1920.

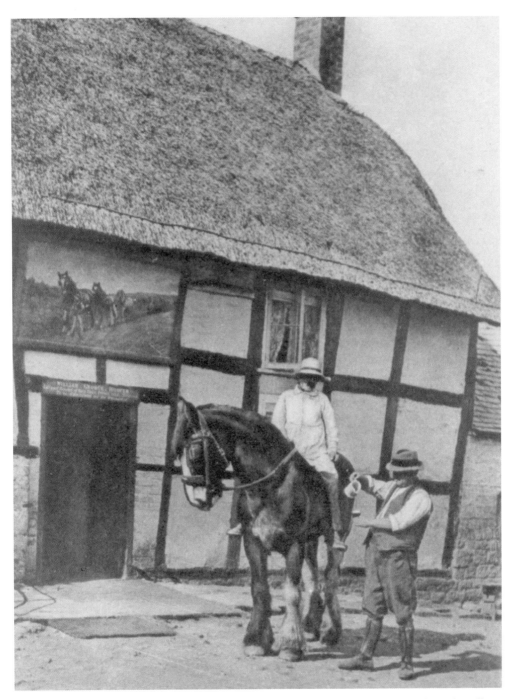

TETBURY TED on one of Mr Nicklin's horses outside the Plough and Harrow pub, with William Hooper, the landlord. Ted rode this horse to the hayfield carrying cider for the men. He had no home, but came from Tetbury and lived in Mr Nicklin's harness room at Holloway Farm. Picture taken c.1910.

A STREET SCENE AT ASHTON UNDER HILL with schoolchildren outside Yew Tree Cottage *c*.1920.

MRS SPIRES, coalman Spires' wife outside one of Dr Roberson's cottages, now demolished, *c*.1910.

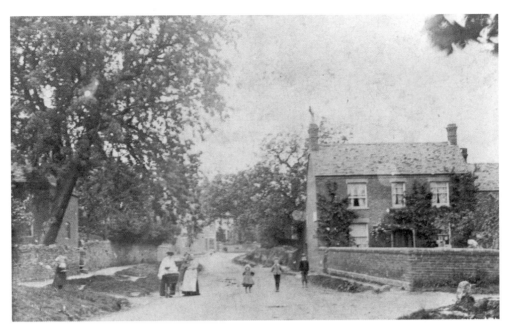

ANOTHER SCENE AT ASHTON UNDER HILL outside Pear Tree Cottage. The pear tree on the left was grafted by Uncle Charles, with four sorts of pears on the one tree.

A VILLAGER FROM ELMLEY CASTLE on a foot-bridge over Merrybrook, 1919.

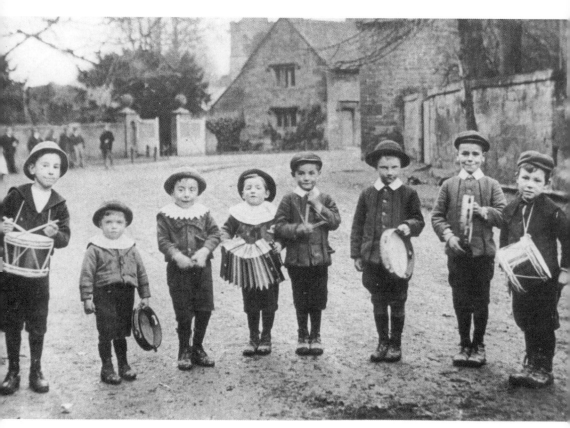

SCHOOLCHILDREN OUTSIDE THEIR SCHOOL in the Vale of Evesham, with melodion, drums and tambourines. 1920.

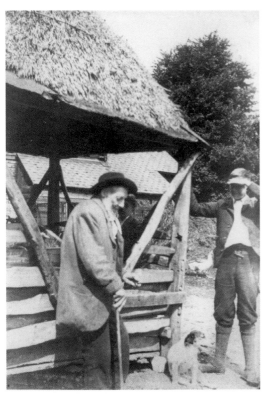

CHARLES SPIRES of Grafton, with young John Crump. Charles was born in 1812 and worked for John Crump's father as a shepherd. He used to recite at Harvest Suppers:

> All you rakish farmers who stay
> late at night
> Mind when you go to bed to choose
> some candlelight.
> Now Betty you go up to bed
> And I'll stay up tonight instead.

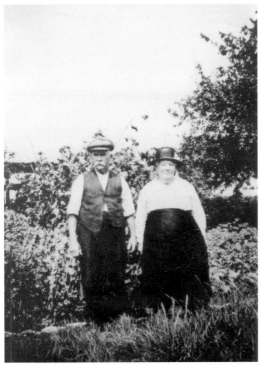

UNCLE JOB AND AUNT POLLY of Beckford. Aunt Polly had a little shop where she sold, among other things, home-made pop which she put in Camp Coffee bottles. Uncle Job had an enormous appetite. After a huge dinner of potatoes, boiled bacon and cabbage, apple pie and custard, he drank cider, went to sleep and snored. They had never heard of the Weight Watchers!

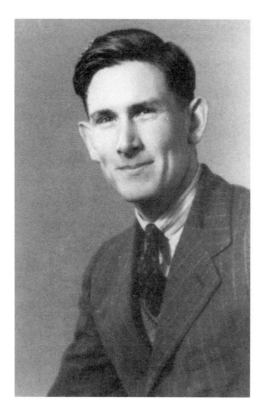

FRED at 21 in 1936. Taken by Blinkhorns of Evesham.

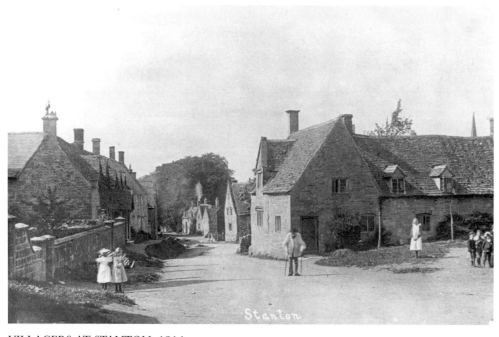

VILLAGERS AT STANTON. 1914.

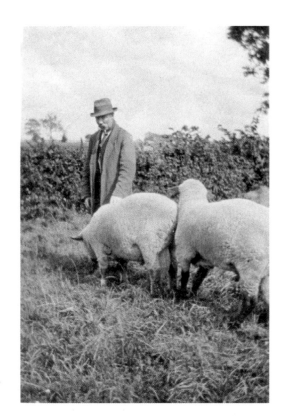

A DUMBLETON SHEPHERD with two rams. 1924.

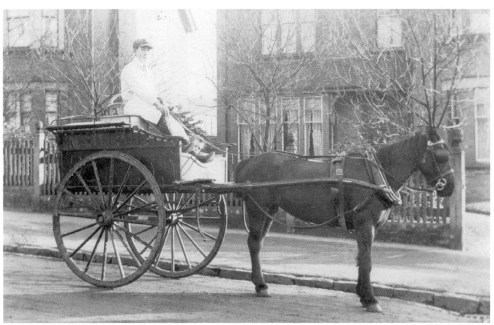

A BUTCHER-BOY outside houses at Pershore. A typical scene in the 1920s. A smart turnout of horse and cart.

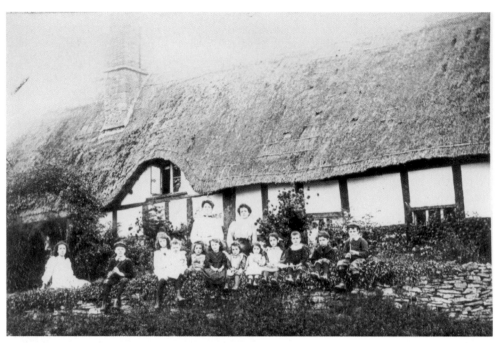

SCHOOLCHILDREN WITH THEIR TEACHERS outside Cross Cottages, Ashton under Hill, in 1917. These thatched cottages had an earth floor in one room in those days.

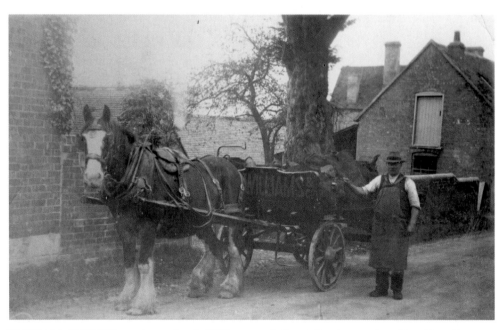

WILLIAM ARCHER, coalman for J. Williams and Co. delivering coal at Yew Tree Cottage, Ashton under Hill. William was no relation to me. Another branch of the Archer clan!

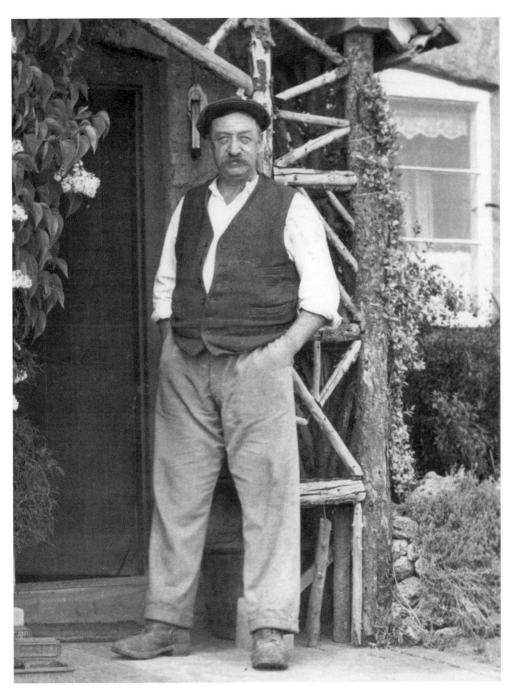

WALTER GREEN of Pidgeon Lane, Overbury, outside his cottage. Walter served in the army in the First World War in the 5th Gloucesters; a bachelor, one-time pig farmer, expert rabbit-catcher and quite famous cricketer. He was known as Bumper Green because of his fast bowling. He knocked out two policemen with his deliveries in 1921. Photo taken in 1930.

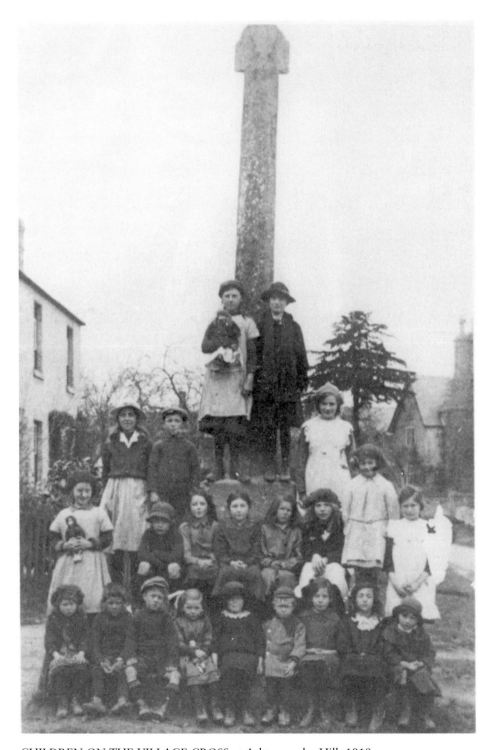

CHILDREN ON THE VILLAGE CROSS at Ashton under Hill, 1919.

THE BAKER'S CART MEETS THE FARM CART at Bricklehampton, 1900.

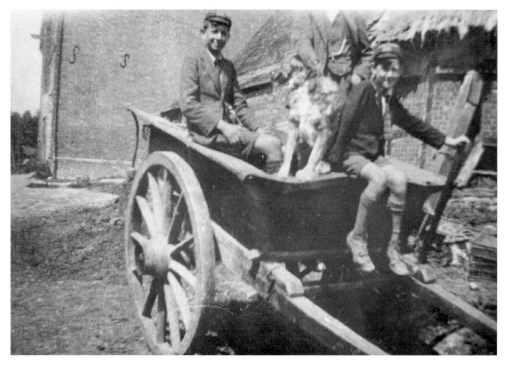

MY BROTHER TOM AND ME on a farm cart at Stanley Farm, Ashton under Hill, in 1928.

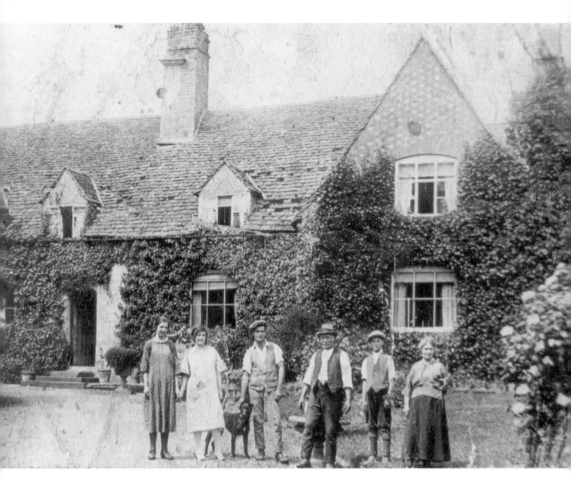

MR AND MRS HARRY BAILEY with Connie, their daughter, Stacey Cotton, Jack and Nellie Whittle and their dog, Jum, outside Old Manor Farm, Ashton under Hill, 1920.

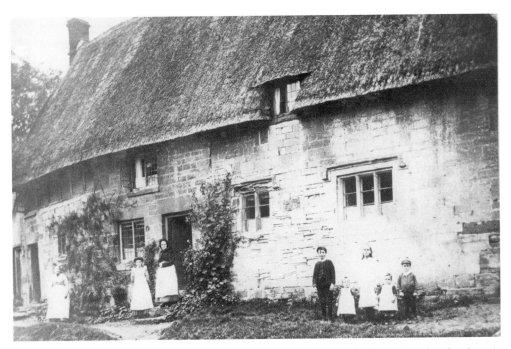

THE NASH FAMILY outside Pixie Cottage, Stanton, in 1910. The horseshoe by the door is upside down – that's bad luck!

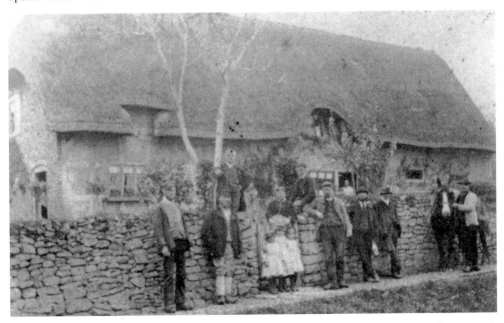

THE CROSS COTTAGES, now Walnut Thatch, Ashton under Hill, in 1880. Bill Seviour is by the walnut tree. This tree was planted on his 21st birthday. Others are Albert Richardson, Mrs Seviour (in the gateway), Jim Barnett (the tall chap) and my uncle, Jim Archer, holding Mr Jeyne's horse.

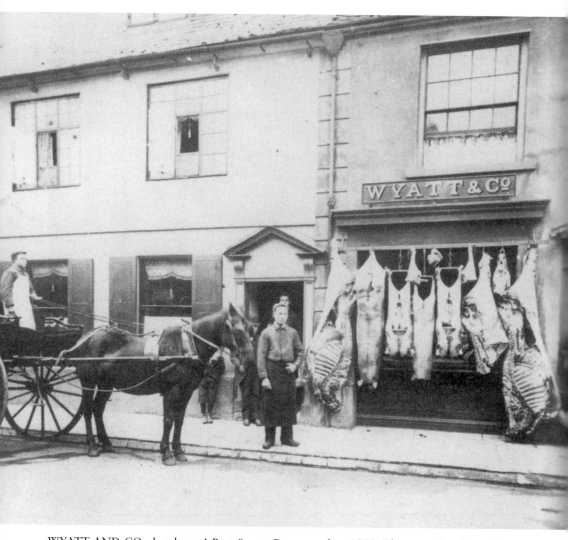

WYATT AND CO., butchers, 4 Port Street, Bengeworth, *c.*1890. They were butchers when my Grandmother, Emma Westwood, kept a fruit shop in Port Street.

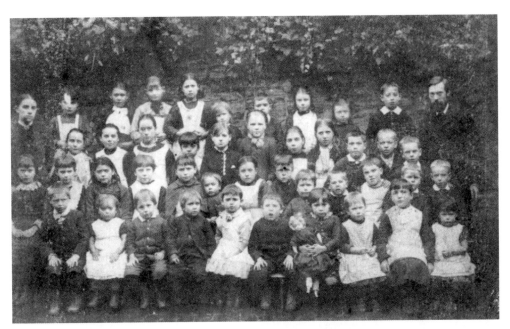

SCHOOL GROUP, Church Street, Evesham, *c*.1900. Edith Witts was a friend of Mother.

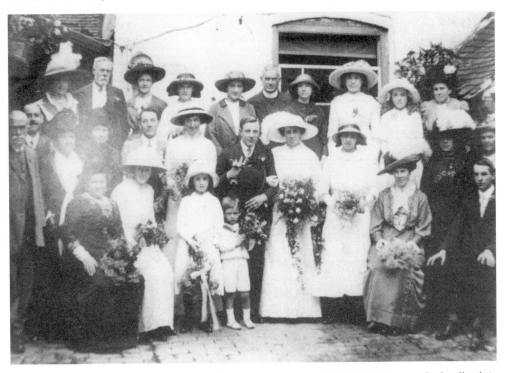

WEDDING GROUP outside the Woolpack Inn in Bengeworth, 1907. Mr Evans, the landlord, is second from the left. His son followed as landlord and was on the RDC with Dad. I believe that his grandson was an engineer with Coulters, the Ford people.

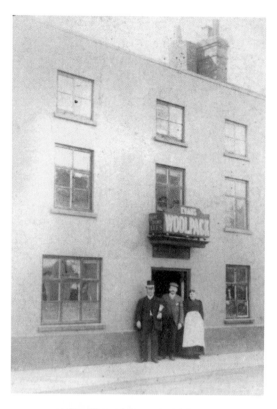

CHARLES EVANS AND MRS EVANS
with Frederick Wheeler the Town Crier, in
the box hat, outside the Woolpack. 1907.

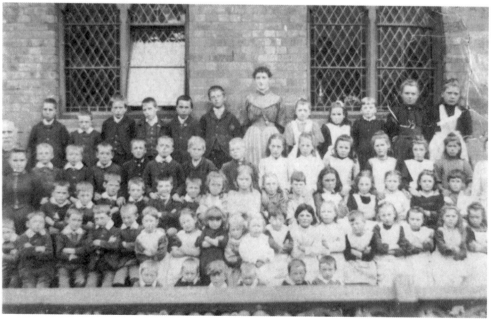

CHURCH LENCH SCHOOL, 1890. The teacher married Mr Percy Curnock whose son, Jim,
I went to school with.

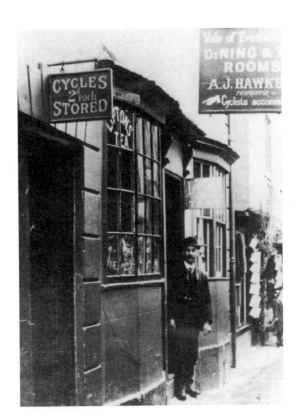

HAWKER'S TEA ROOMS in the Allie
at Evesham. Mr Hawker was famous
for lardy cakes. He was a Methodist
local preacher. 1910.

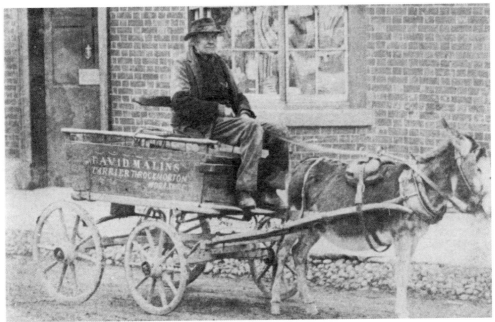

THE THROCKMORTON CARRIER lived a few miles from Pershore. His vehicle with the
donkey is a miniature four-wheeled dray. His seat appears to take up half the carrier cart.

A PICTURE OF JONATHAN HULL
who lived at Chipping Campden in
Gloucestershire.

NORAH RUSSELL with baskets of
apples after picking fruit at Tythe
Farm, Gretton, 1936.

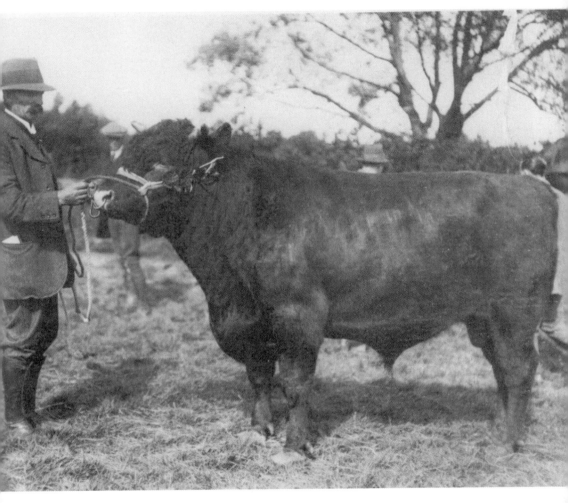

MR T. R. RUSSELL of Tythe Farm, Gretton, showing one of his Shorthorn bulls which won a prize at Winchcombe Show, 1920. Mr Russell used to be a judge of Shorthorns.

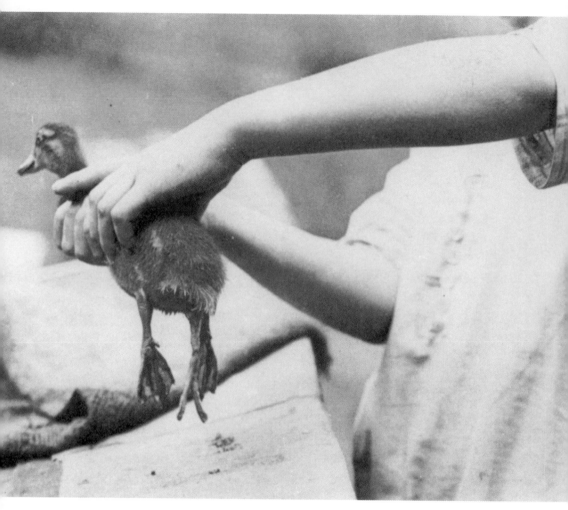

NORAH RUSSELL holding a Runner duck with three legs at Tythe Farm, Gretton, *c*.1922.

SECTION THREE

Events

A SEDGEBERROW FAMILY all dressed up ready to go on an outing to Weston-super-Mare. Tom Warren, known as 'Stodge', is wearing an engine driver's cap. He was the village roadman at Ashton under Hill for many years. Previously he drove one of Bomford's steam traction engines, ploughing the Vale land. He followed Ashton's football team with his jar of cider to pep up the players. This party is ready to walk to Ashton under Hill LMS station *en route* for a day at the seaside.

ASHTON CLUB ON TRINITY MONDAY; Revd Joseph Harrison with John Clements the club secretary behind him, James Cotton's father on the right with the bowler hat and my grandmother, Mary Archer, the stout woman in front of him. *c*.1885

Opposite page, bottom right:
ASHTON CRICKET TEAM, 1923, outside the new pavilion given by Sir James Curtis. Left to right at the back: Syd Rowland, Chas Stephens, Billy Clements. Middle row: Mr Johnson, Fred Tandy, Frank Barnes, Frank Johnson, Fred Griffin, Albert Driver, George Garland, Ewart Morrison, High Clements, Chas Taylor. Front Row: Fred Kempton, Chas Knicklin, J.C. Nicklin, Sir James Curtis, Noel Rogers, Harry Stratford. Ewart Morrison, a good all-rounder, played for Gloucestershire for a couple of seasons.

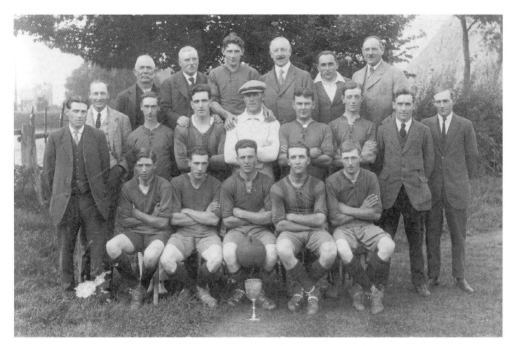

ASHTON FOOTBALL CLUB. 1922. This team won the First Division Cheltenham League for several seasons, the North Gloucestershire League and the Cheltenham Hospital Cup. Left to right at the back: 'Stodge' Warren, J. C. Nicklin, Sid Rowland, Sir James Curtis, Charlie Nicklin, Hugh Clements. Middle row: 'Stitch' Price, J. D. Field, Frank Barnes, Fred Griffin, Harry Cotton, Jack Lampitt, Willie Hunt, Holmes (Sir James' chauffeur), – Clements. Front row: Leslie Hunt, Sidney Bell, Percy Griffin, Willie Clements, Arthur Hunt.

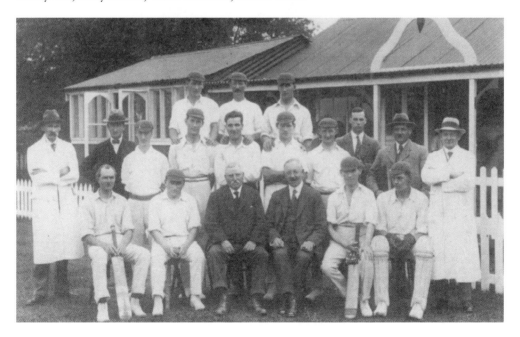

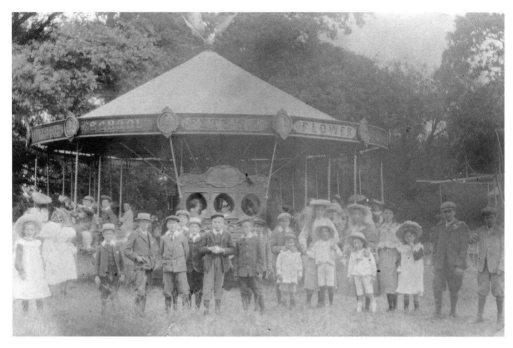

CHILDREN BY THE JINNY HORSES at Dumbleton Flower Show, 1910.

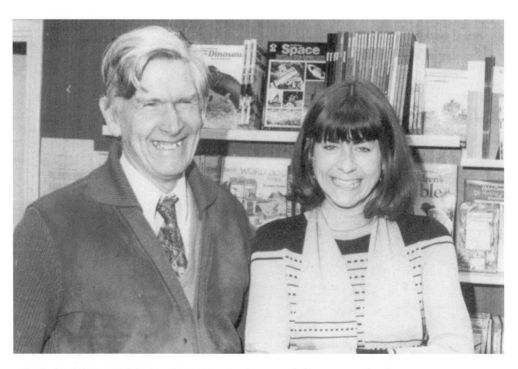

FRED ARCHER WITH PAM AYRES at Evesham Bookshop signing books. 1978.

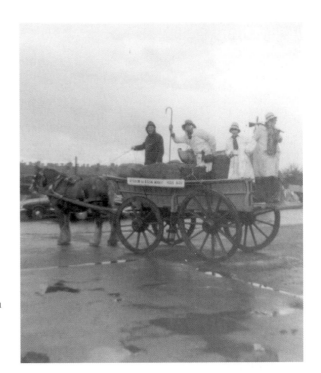

FRED ARCHER, RAY SATCHELL AND NICHOLAS with Fred's wagon at Simon de Montfort's Parade in Evesham, celebrating 700 years since the Battle of Evesham. 1965.

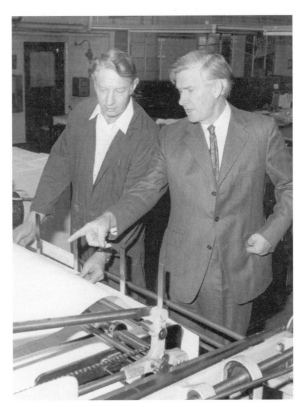

FRED WITH THE PRINTER, EBENEZER BAYLISS, of Worcester, watching his first book coming off the press. 1967.

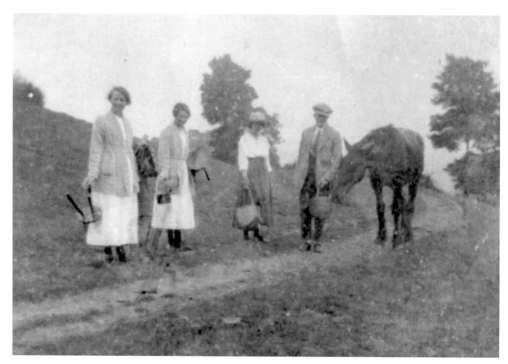

A PICNIC ON BREDON HILL; note the stool and the kettle. Amy, Lily and Eva Randall with Harvey Savage, 1925.

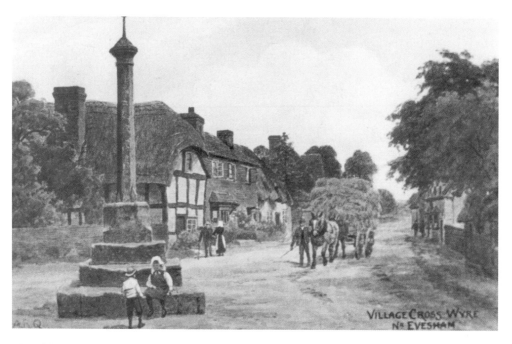

VILLAGE CROSS, Wyre near Pershore. A load of hay and children on the cross. 1914.

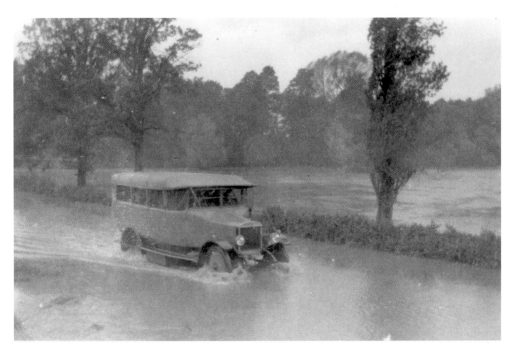

A SMALL CHARABANC going through the floods along the Waterside at Evesham, 1920s.

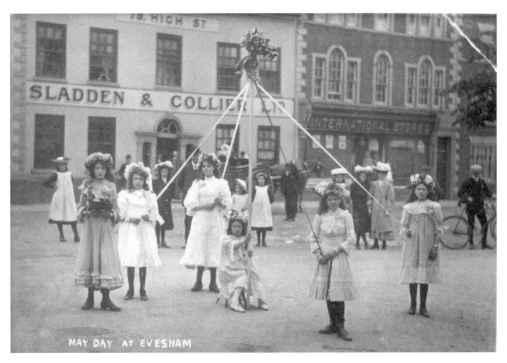

MAY DAY IN EVESHAM HIGH STREET outside Sladden & Collier's premises. They were a local brewery. 1913.

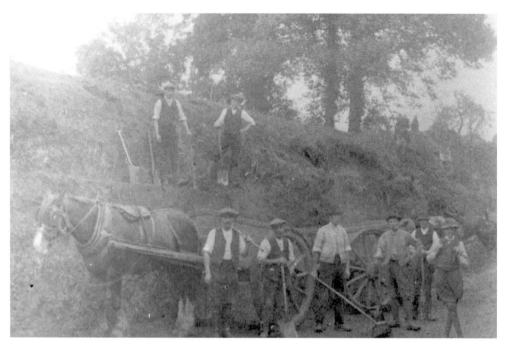

ROAD-MAKING NEAR PERSHORE, 1919 – all hand-work and horse and cart.

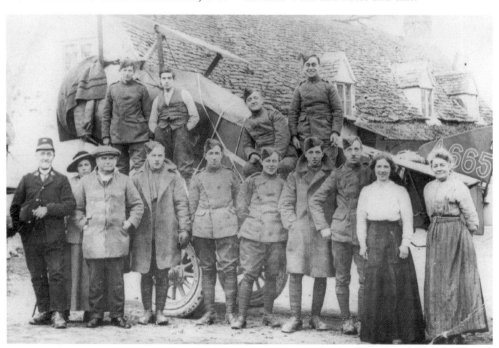

VILLAGERS AND SERVICEMEN OUTSIDE THE HOB NAILS INN at Little Washbourne during the First World War. The aeroplane is on a trailer *en route*. Mr Fletcher, the landlord of the inn, is standing next to the postman, second from the left.

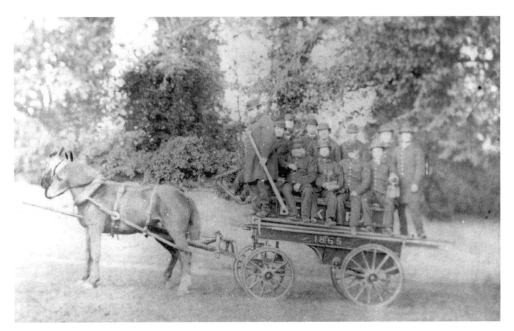

BECKFORD FIRE BRIGADE in 1865. Among the team is a Mr Foort, grandfather of Reginald Foort the organist. This team had its photograph taken on its way to a fire at Ashton under Hill by a travelling photographer called Trotting Johnny, from Alderton. The fire brigade also saved the house of Nathan Burge as he lay in his coffin at Beckford. He could have had an early cremation!

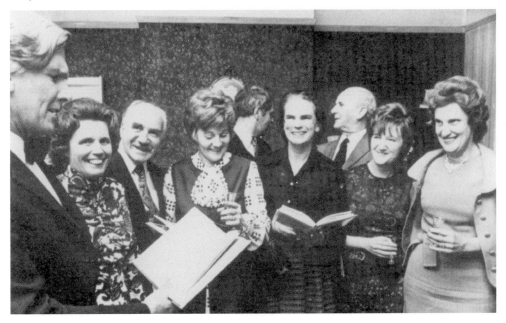

LAUNCH PARTY AT THE BECKFORD HOTEL for my second book *Under the Parish Lantern.* 1968.

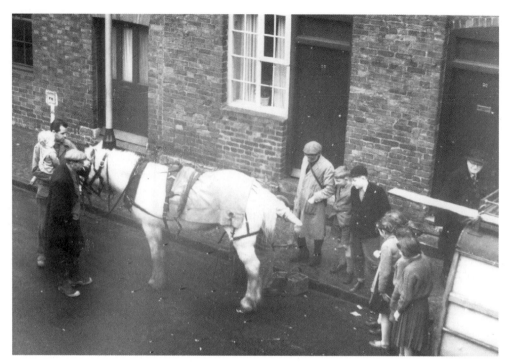

SHOEING A MARKET GARDENER'S HORSE in Evesham. 1950.

BECKFORD HANDBELL RINGERS. They used to entertain at village concerts. Picture taken in 1925.

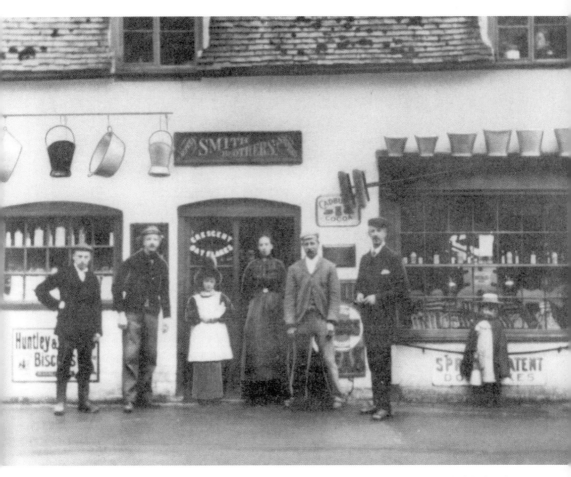

SMITH'S STORES at Beckford, 1913. Smiths were in business for many years, a reliable family firm. They had trestle tables in the school every St Thomas' Day, 21 December, selling blankets and winter clothes which the village women bought with their Mumping Money. Mumping was practised every St Thomas' Day. The women went early in the morning to the better houses and collected money and apples by saying: 'Bud well bear well, God send you well. A bushel of apples to five on St Thomas' Morning.'

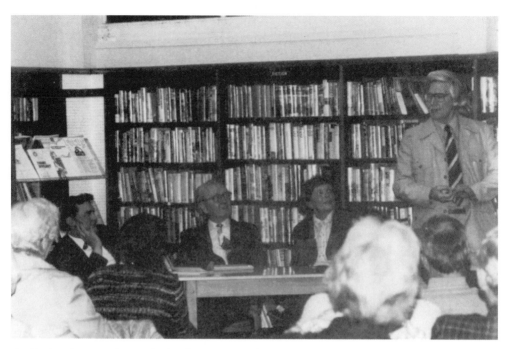

FRED ARCHER with Winifred Foley, Harry Bedington and Keith Morgan speaking at Coleford Library, 1970.

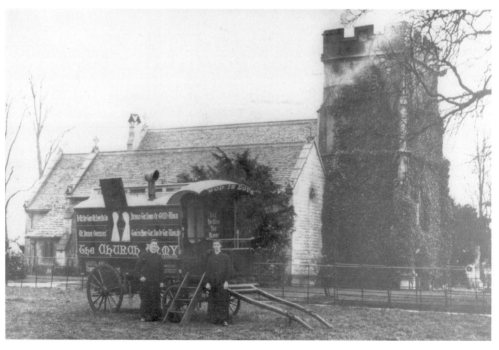

A CHURCH ARMY CARAVAN in front of a Gloucestershire church, 1920s. These vans were taken from one village to another by a horse. I had the job of moving this one.

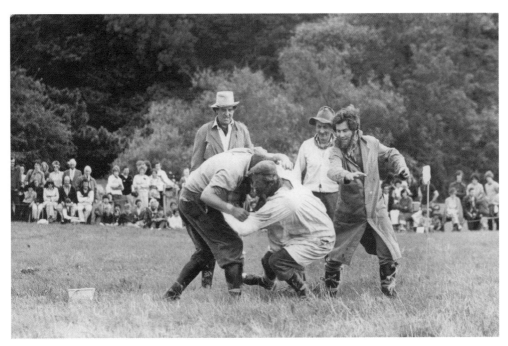

SHIN-KICKING, a rural form of wrestling, at Pershore Medieval Fair, 1970. I revived this rough sport which used to take place at Dovers Hill Costwold Olympics from the reign of James I.

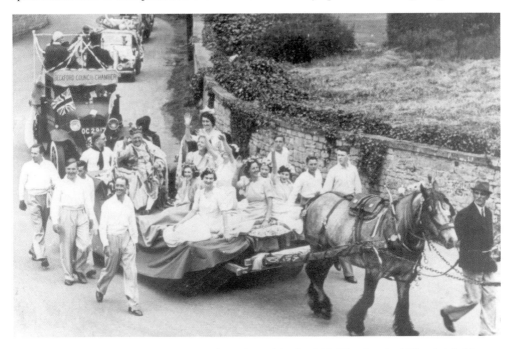

EVESHAM HOSPITAL GALA coming through Beckford, 1928. The Carnival King is Mr Mason, the Queen Signora Vercelli. The Chevriolet lorry belonged to Greeves Bros. of Conderton.

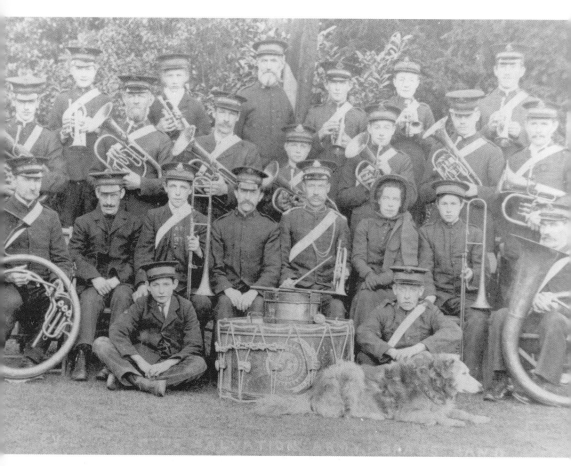

EVESHAM SALVATION ARMY BAND in 1907. Dad is on the right with the euphonium. He played from 1895 until 1913.

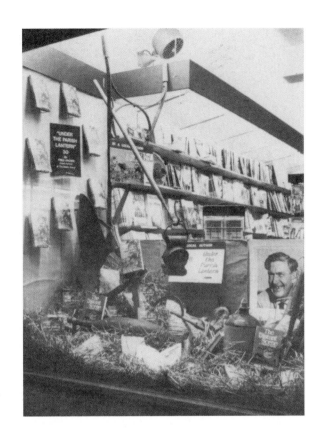

WINDOW AT W. H. SMITH'S,
Evesham, in 1968, publicizing my
book *Under the Parish Lantern*.

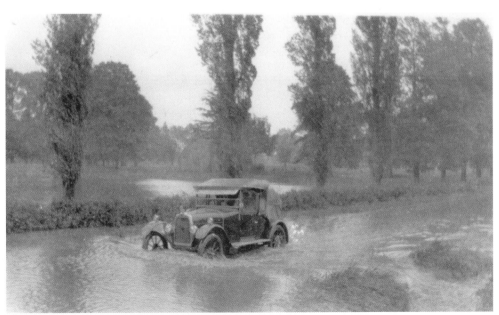

ANOTHER FLOOD PICTURE FROM EVESHAM.

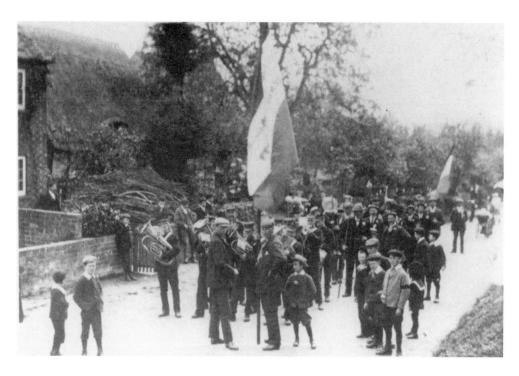

ASHTON CLUB PROCESSION on Trinity Monday, with Alderton Brass Band. It was a Sick and Dividend Club started in 1876 by Doctor Packer from Cheltenham.

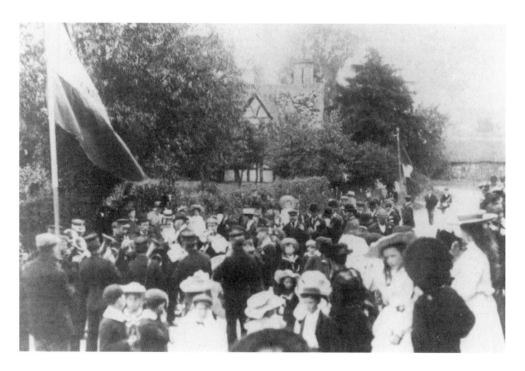

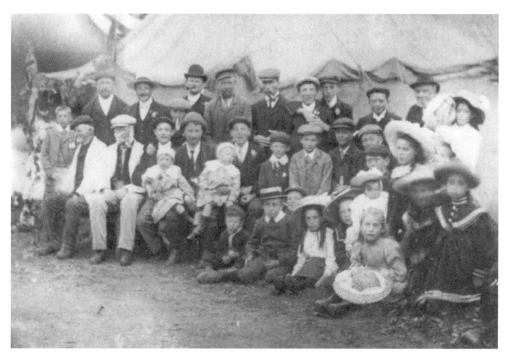

OUTSIDE THE MARQUEE where the club had dinner. 1910.

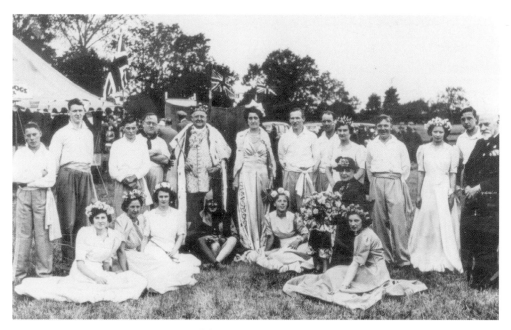

EVESHAM HOSPITAL GALA at Beckford, 1928, with Mr Mason the Carnival King and Signora Vercelli the Queen.

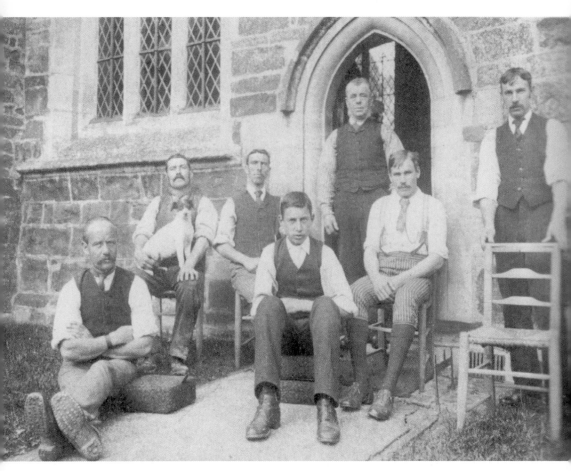

BELL-RINGERS OUTSIDE A VILLAGE CHURCH, *c.*1913. Note the knee breeches and the hob-nailed boots.

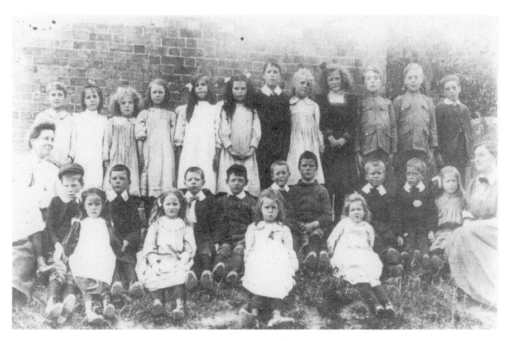

THE VILLAGE SCHOOL at Ashton, 1917. The two boys in uniform are Dr Roberson's sons.

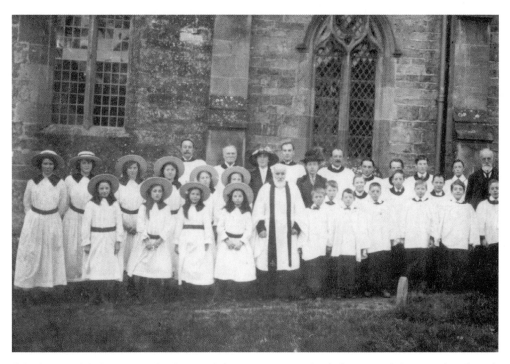

ST BARBARA'S CHURCH CHOIR at Ashton in 1913 at the dedication of the new churchyard. Revd Margetts, Dr Roberson on the right with a beard.

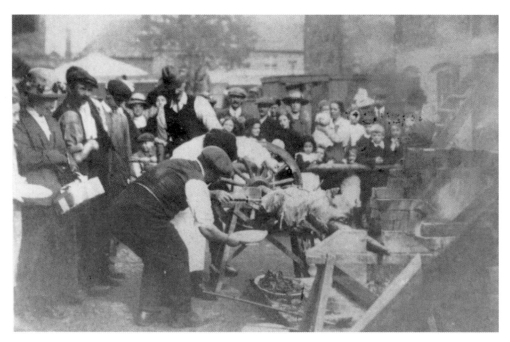

PIG ROAST AT THE VAUXHALL INN on Evesham Mop Day, 1913. Albert Porter was the licensee from 1912 to 1928.

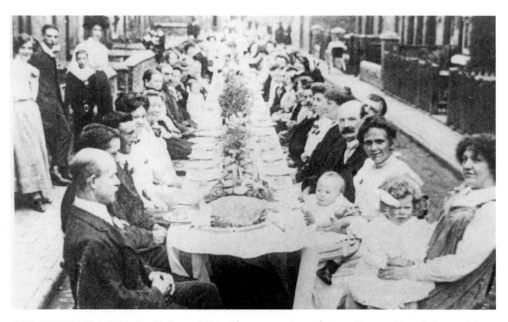

CORONATION DINNER, 22 June 1911. The coronation of King George V and Queen Mary. This photo was taken in Avon Street, Evesham, known as Magpie Lane when I was a boy. The Coronation Dinner planned for King Edward VII's coronation was cancelled because of his illness. This resulted in a riot among the Evesham folk.

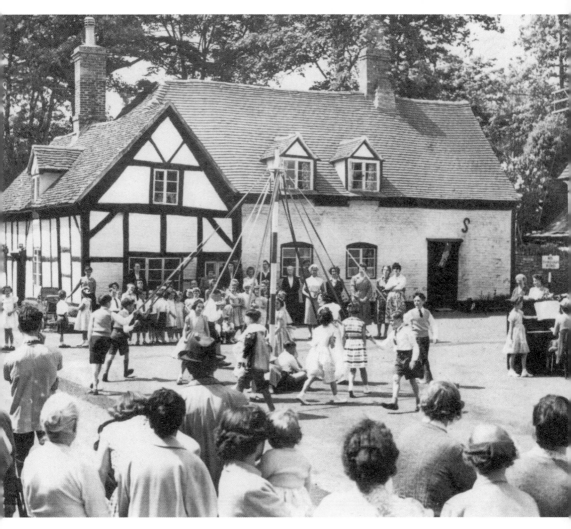

MAYPOLE DANCING AT ELMLEY CASTLE on Oak Apple Day, 24 May 1960. This dancing to celebrate King Charles' escape by hiding in the Oak Tree at Boscobel was revived by the village schoolmaster in 1960.

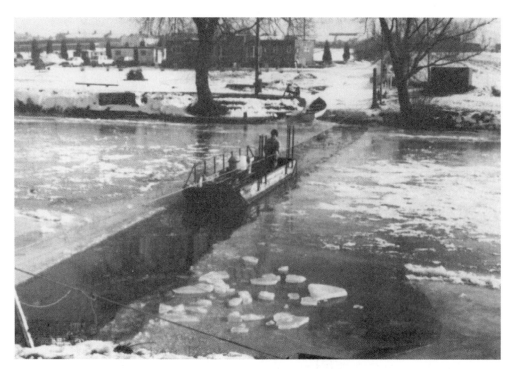

THE RIVER AVON AND HAMPTON FERRY, frozen in February 1985.

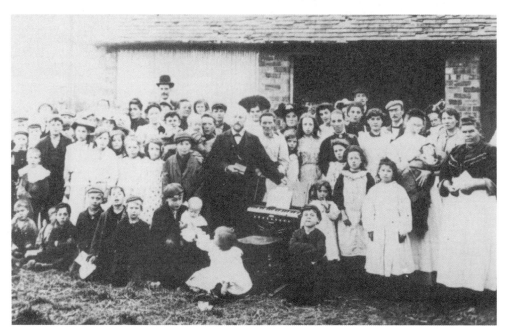

ALDINGTON BAPTIST SUNDAY SCHOOL in 1905. They were celebrating their Sunday School anniversary by singing around their harmonium.

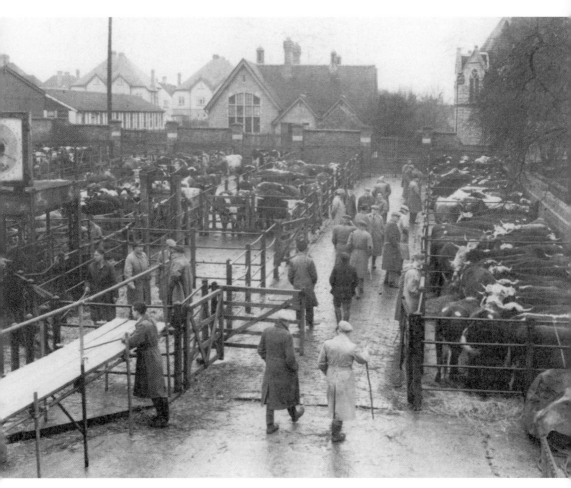

EVESHAM SMITHFIELD CATTLE MARKET in 1970. The event is the Candlemas Fair. The market was that of Mr Grant Repton, the grandson of the founder of Edward Grant Righton. In its heyday the market was well situated, adjoining the Great Western Railway station where the cattle were loaded by the dealers for all parts of England. I notice that here in 1970 the cattle are practically all Herefords – no charolais or other foreigners!

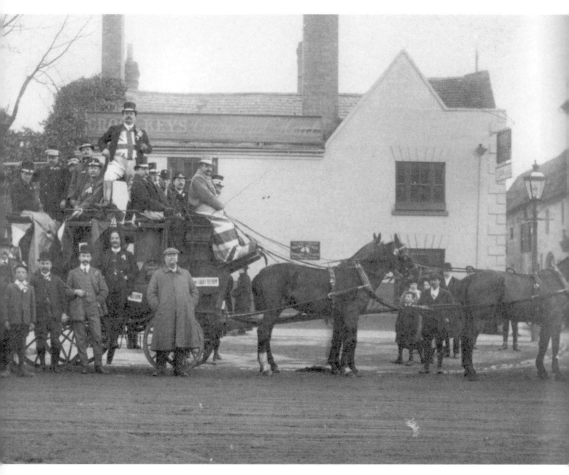

POLLING DAY OUTSIDE THE CROSS KEYS *c.*1907. This would be for a Tory candidate. The last Liberal MP was Edward Holland, Squire of Dumbleton, in the late nineteenth century.

WAITING FOR ROYALTY at Evesham GWR station. They were expecting guests to the royal wedding in 1908 between Princess Louise Françoise, youngest daughter of the late Comte de Paris and sister of the Duke, and Prince Charles of Bourbon Sicily. The wedding took place in a tin Tabernacle, the place of worship of the Evesham Roman Catholics, not at the chapel at Woodnorton, built specially for the occasion by the Duke but which was not registered for marriages: a great disappointment to the Duke and Duchess.

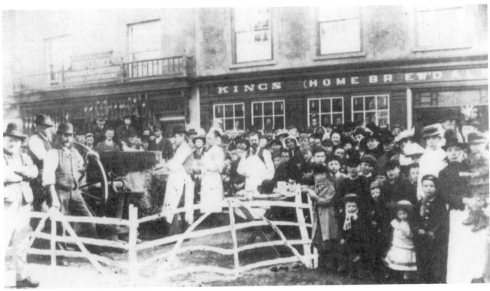

OX ROAST outside the Kings Head in Evesham, 1900. The Kings Head was a coaching inn in High Street. It was here we stabled our cob when we went shopping. Latterly the inn became Timothy Whites and is now a hardware shop.

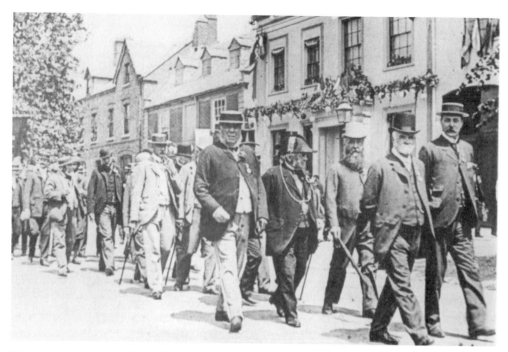

THE MAYOR AND CORPORATION, Evesham, 1887. Isaac Morris, the Mayor, on Mayor Choosing Day. Isaac Morris was uncle of Eleanor M. Morris, ATCL, who was Principal of Evesham Preparatory School which I attended for 5 years.

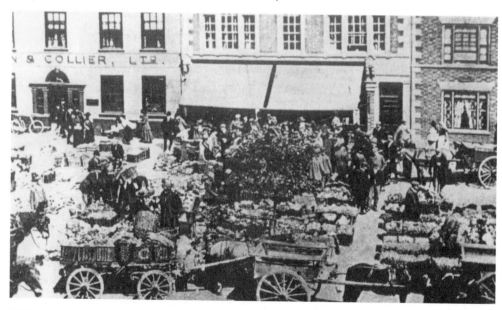

MARKET DAY IN EVESHAM HIGH STREET, 1920. Fruit and vegetables used to be sold in the High Street when the Cattle Market occupied the Smithfield Market every other Monday. The hampers on the dray have the owners' initials stamped on them.

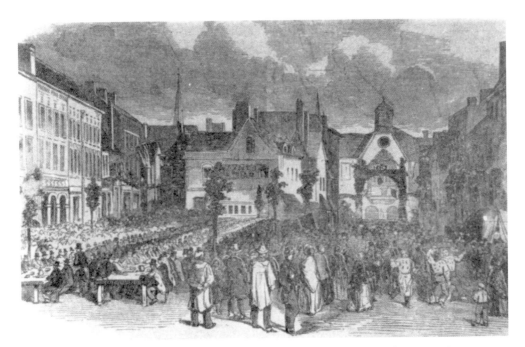

DINNER AT EVESHAM to celebrate the opening of the Oxford, Worcester, Wolverhampton Railway in 1850, later the GWR from Hereford to Paddington.

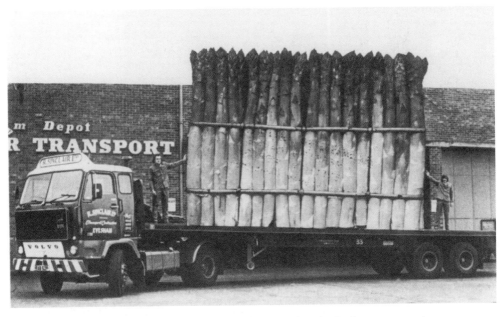

SINCLAIR'S TRANSPORT with a huge replica of a hundred of asparagus. Asparagus was known locally as 'gras', 2000 acres being grown in the Vale of Evesham before the Second World War. A hundred of 'gras' is really 120 buds, known as the long hundred, similar to 13 being the baker's dozen.

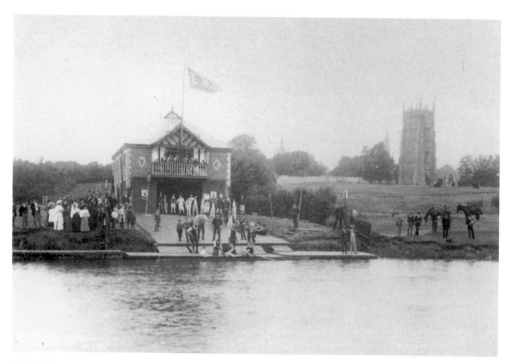

THE ROWING CLUB PAVILION with boats on the River Avon. 1890. Evesham Regatta, held on Whit Monday, was known as the Henley of the Midlands. Crews came from all over the country to race on the river.

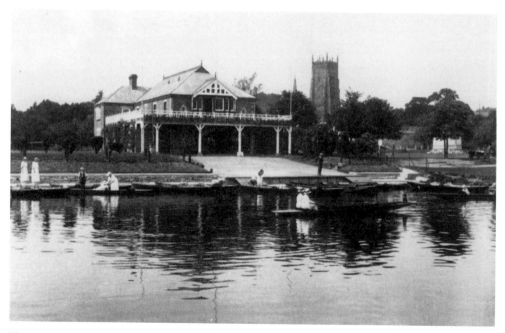

THE ROWING CLUB PAVILION, 1920.

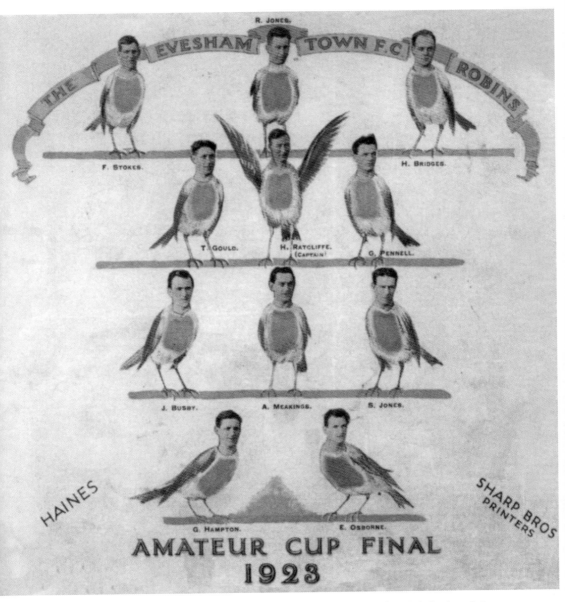

AMATEUR CUP FINAL, 1923, when Evesham Town FC lost to London Caledonians 2-1.

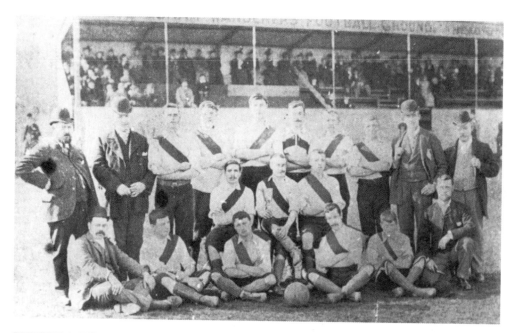

EVESHAM WANDERERS FOOTBALL CLUB, 1892. Some of the names are familiar: H. Goodall, who founded Goodalls Motor Accessories, George Brearly who had a mineral water factory which was famous locally, George Sleath, an Evesham draper, and Fred Roberts, a painter and decorator.

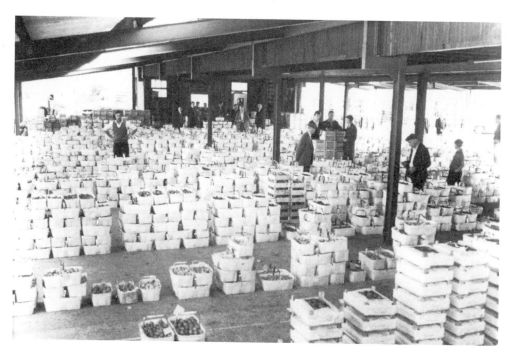

PLUM SALE by auction at Smithfield Market, Evesham, 1960.

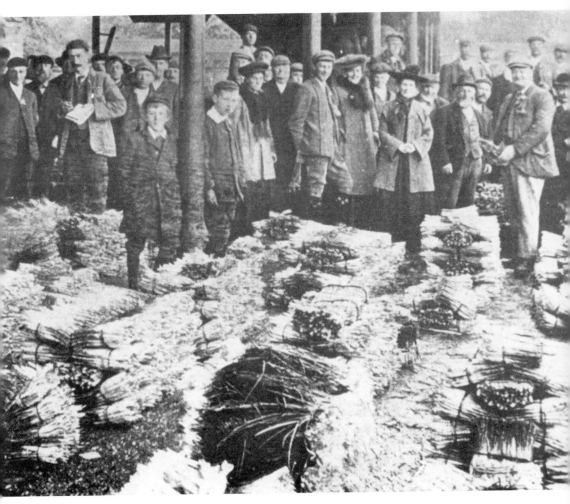

ASPARAGUS SALE at Evesham, 1912. The asparagus is bundled in packs of 120 buds tied with a withy. The withies, or willows, were grown by the River Avon especially for bundling asparagus and were sold by basket-makers, Mr Heritage in particular.

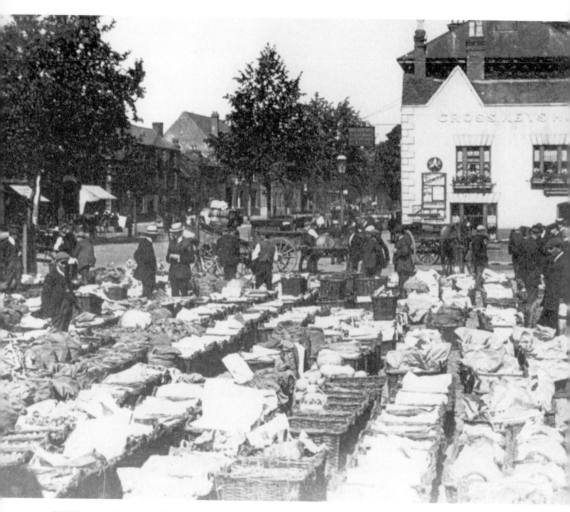

PLUM MARKET in High Street, Evesham, at the turn of the last century. Notice that the plums were packed in pot hampers. Each hamper held 72 lb. of plums. The same hamper held 72 lb. of pears, 60 lb. of apples or 40 lb. of sprouts. These hampers were made from withies grown on the banks of the Avon.

SECTION FOUR

Places

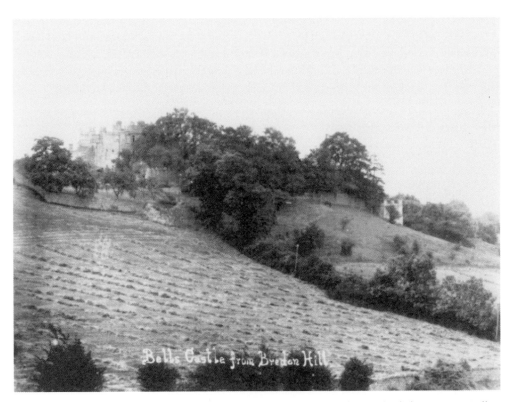

BELLS CASTLE, Kemerton, high on Bredon Hill. This sham castle was built by Captain Bell, a smuggler and privateer. He lived here early in the nineteenth century and was supposed to have smuggled tobacco and spices from the East to Bredon Dock. The legend has it that the spices can be smelt in the cellar and when the moon is full a ghost-like stage-coach passed driven by Spring Heeled Jack.

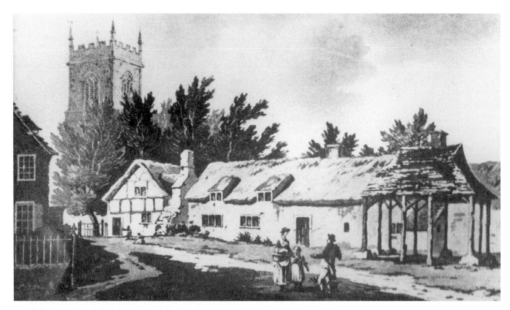

A DRAWING OF THE OLD RED LION AT BECKFORD at the time of the enclosures of 1784. It was here the Enclosures Award was signed for Beckford and Ashton under Hill. A legal gentleman from Northampton instituted the Enclosure and he was afterwards murdered by an Ashton under Hill man. The whole of the property is gone except the house partly showing on the left.

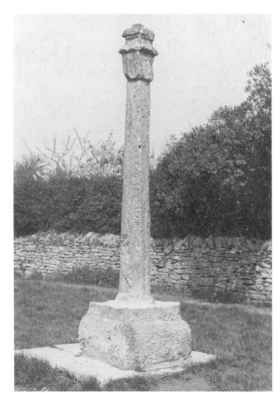

THE OLD CROSS at Elmley Castle near the church.

WILLERSEY. The car outside is a 16 hp Sunbeam
tourer similar to Dad's car.

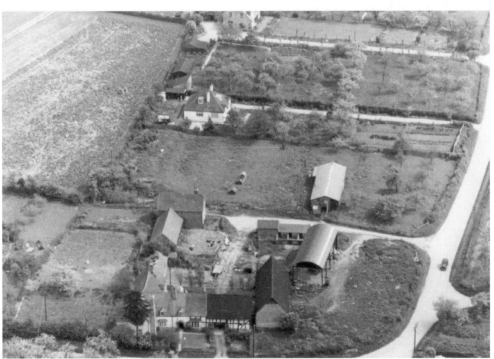

AERIAL VIEW OF STANLEY FARM, Ashton under Hill, with some of my cattle in the yard
adjoining the Old Granary. 1958.

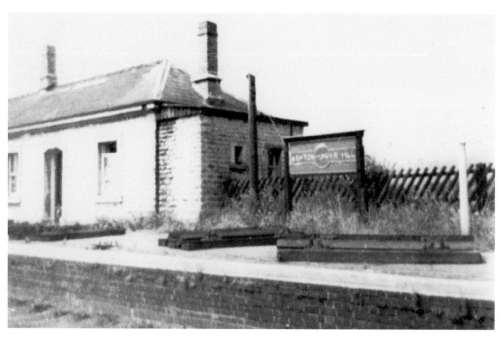

ASHTON UNDER HILL STATION with the line pulled up, in 1962. The line was laid as a branch line from Ashchurch to Barnt Green in 1864. The building is the ladies waiting room.

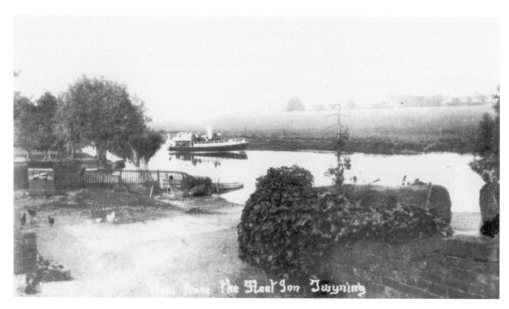

ONE OF BATHURST'S STEAMERS from Tewkesbury on the River Avon at Twyning. These steamers plied from Tewkesbury to Evesham and Stratford-on-Avon.

ASHTON SCHOOLCHILDREN awaiting the meet of the Crome Hounds, 1913, outside Holloway Farm.

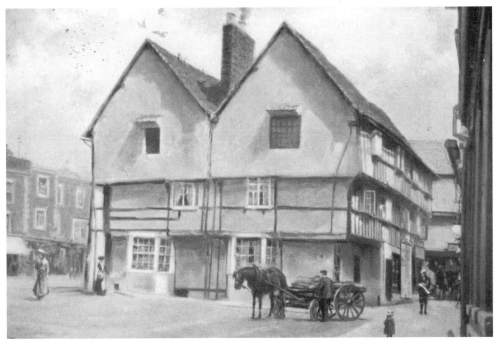

THE BOOTH HALL, Evesham, known as The Round House, as it was in 1900.

THE KING AND QUEEN STONES on Bredon Hill. A Court used to be held there and ailing children were pushed between the stones to cure them.

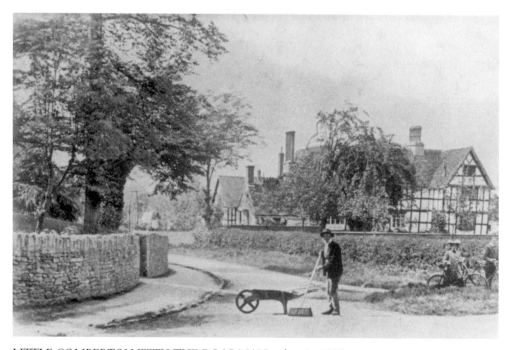

LITTLE COMBERTON WITH THE ROADMAN, taken in 1913.

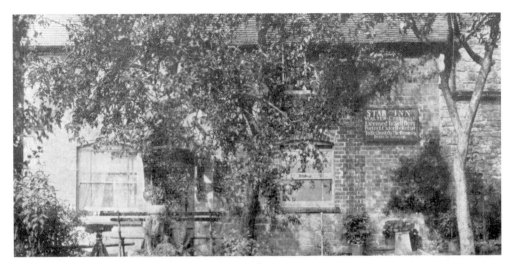

THE STAR INN, Ashton under Hill shown in the 1920s. A plaque inside reads:
> As a bird is known by his note
> So a man is known by his conversation.
> Swearing strictly prohibited.

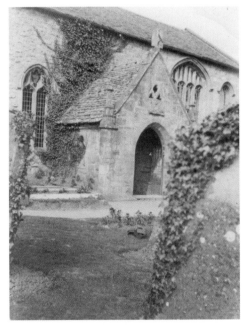

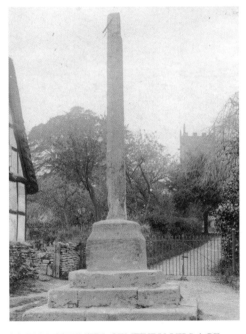

THE NORMAN PORCH OF ST
BARBARA'S CHURCH at Ashton under
Hill seen here in 1930. It was the only
church dedicated to St Barbara until a recent
dedication in East Anglia. There is a St
Barbara's window in Tewkesbury Abbey.

THE FIFTEENTH-CENTURY VILLAGE
CROSS at Ashton under Hill before the Lych
Gate was erected, pre-1918.

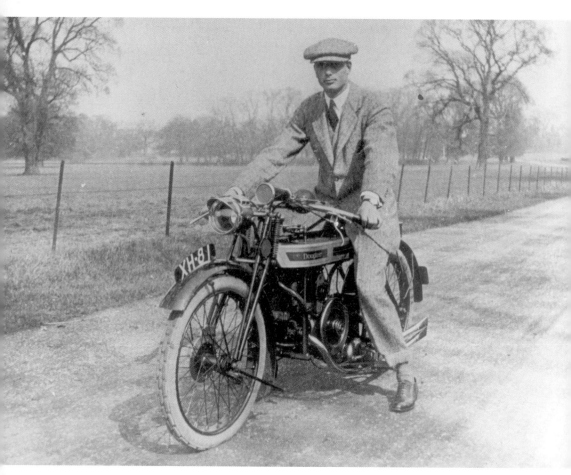

AN OLD MOTORBIKE outside Overbury Park, 1920s.

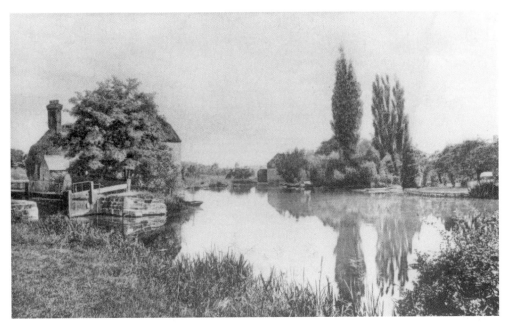

FLADBURY LOCK AND MILL on the River Avon, 1920s.

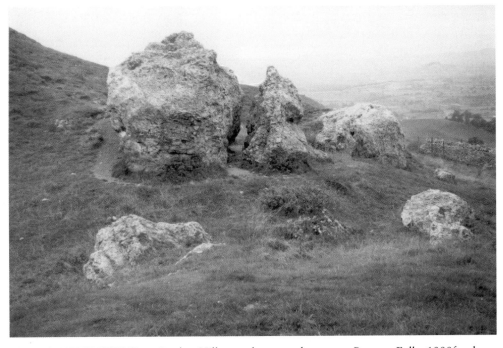

THE BANBURY STONE on Bredon Hill near the tower known as Parsons Folly, 1000ft. above sea level. The legend says that every time the stone hears Pershore clock strike 12 it goes down to the river to drink.

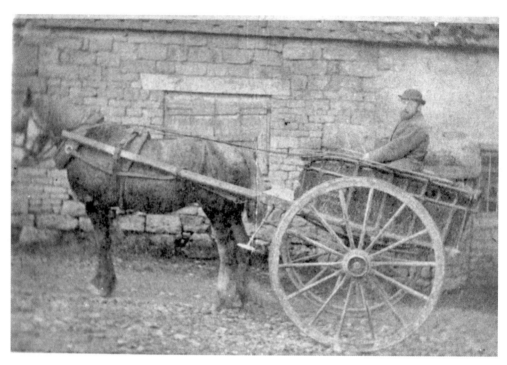

A RAG AND BONE MAN coming through Beckford, 1910.

PARK LANE, Beckford, which leads to the Home Farm that belonged to Captain Case. Opposite this lane lived Jimmy Pardington, his legendary bailiff and a fine horseman who grew his own tobacco.

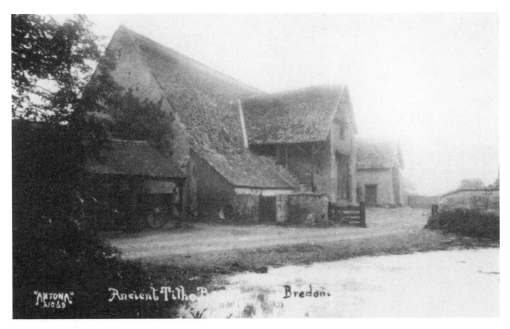

BREDON TYTHE BARN, a Cotswold stone barn now belonging to the National Trust.

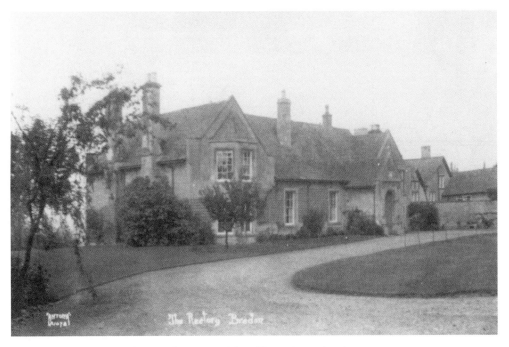

THE RECTORY at Bredon, in that part of the village above the river.

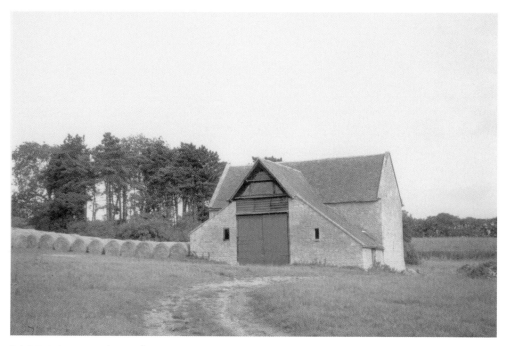

LA LU BARN, Bredon Hill.

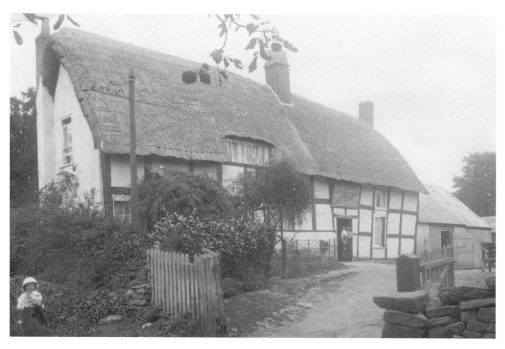

THE PLOUGH AND HARROW INN at Ashton under Hill, Pre-1914.

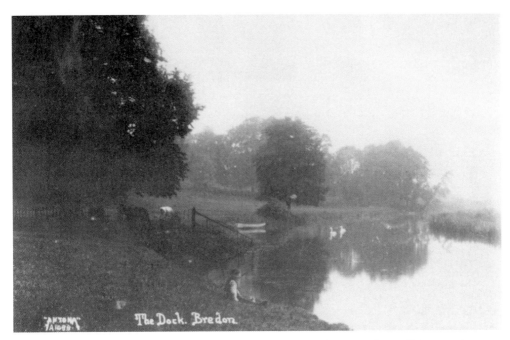

THE DOCK AT BREDON, This used to be busy with traffic taking hay off the meadows on barges to the Black Country via Tewkesbury and the Severn. The barges brought back coal for the Bredon Hill villages. Now the river is busy with pleasure craft.

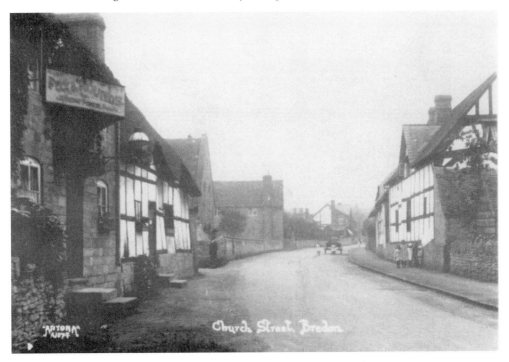

THE FOX AND HOUNDS at Bredon in Church Street, well known for its catering.

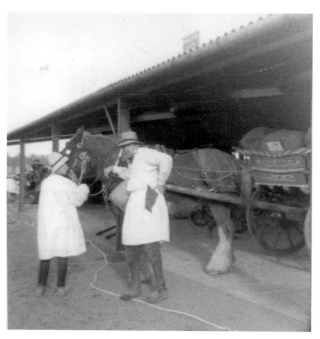

MYSELF WITH A WAGON at the Simon de Montfort celebrations in Evesham. 1965.

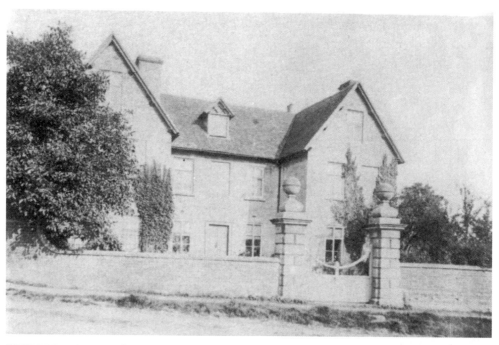

HIGFORD HOUSE, Ashton under Hill, named after Revd Higford, a former vicar who lived there. It was once the home of Admiral Vernon who defeated the fleet at Portobello and introduced rum into the Navy to prevent scurvy. He was known as Old Grog. Picture taken in 1910.

THE FISH INN on top of Broadway Hill in 1905.

THE HOME OF GENERAL SIR FRANCIS DAVIES in Elmley Castle.

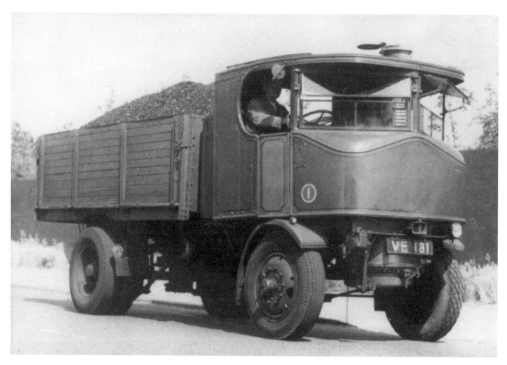

A STEAM WAGON on the main Cheltenham to Evesham road, at an Ashton under Hill farm. 1928.

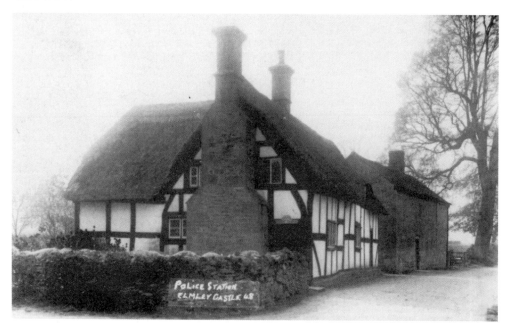

THE POLICE STATION at Elmley Castle, a typical Worcestershire cottage. The outside chimney would be built before the cottage, thus claiming the building site.

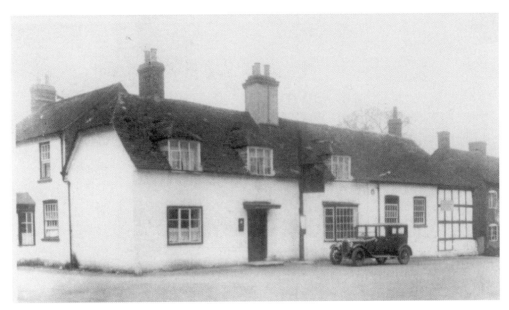

THE QUEEN ELIZABETH INN, Elmley Castle, named after the visit, in 1575, of Queen Elizabeth to Elmley Castle. As she entered the village, she was met by the squire, William Savage, at a spot still commemorated today, called Bess Cap.

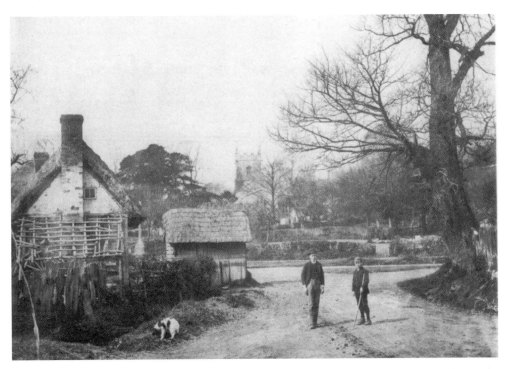

JOHN BALDWYN AND HUGH CLEMENTS at Ashton under Hill, 1890. This shows the orchard opposite before the cottages were built in 1903.

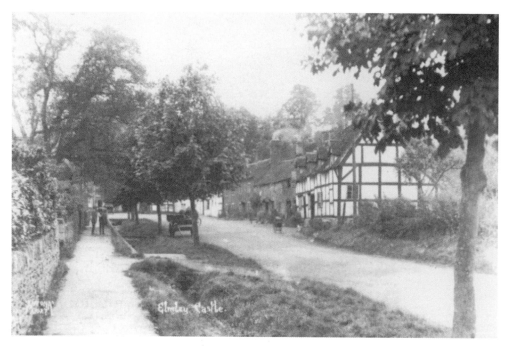

ELMLEY VILLAGE STREET showing the brook known as Merrybrook. If a villager fell into this after drinking too much cider at the inn he was reckoned to be the unofficial mayor of Elmley Castle for a year.

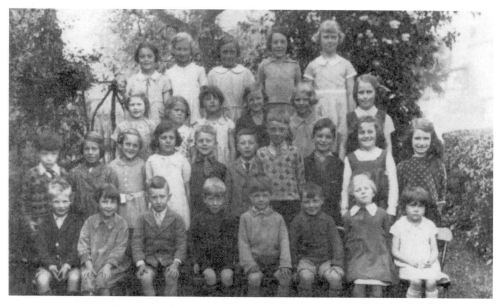

ELMLEY CASTLE SCHOOL, 1936.

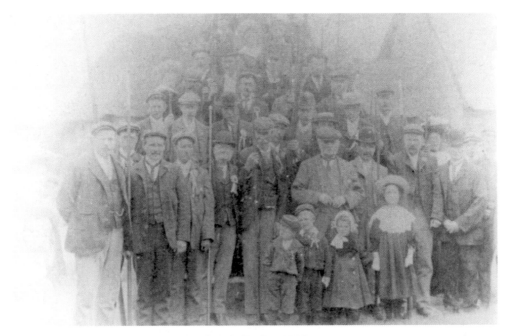

ANOTHER PHOTOGRAPH OF ASHTON CLUB *c.*1905.

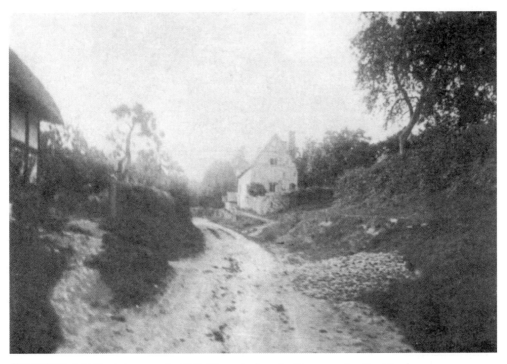

COTTONS LANE, Ashton under Hill. Named after the Cottons who lived in the cottage seen on the left. The heap of stones is waiting to be broken by Joe Barnett who quarried them on Bredon Hill. 1890.

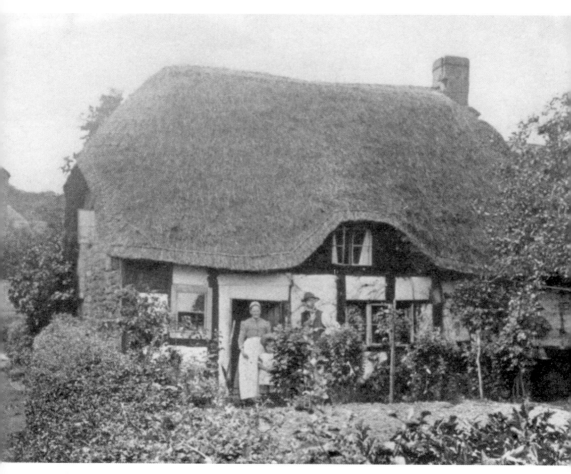

COALMAN AND MRS SPIRES outside their cottages in 1905.

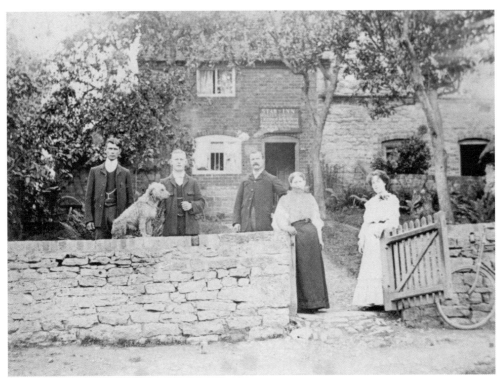

THE STAR INN, Ashton under Hill, with John Cresswell, Walter Cresswell and family *c.*1900.

STANLEY FARM, Ashton under Hill, with Dad, Mother, sister Clarice and Rip the dog. 1925.

THE OLD BAPTIST CHAPEL, Ashton under Hill, pre-1924, when a new Free Church was built on the site. The Old Chapel was given by Mr New of Higford House and was sponsored by the Bomford family.

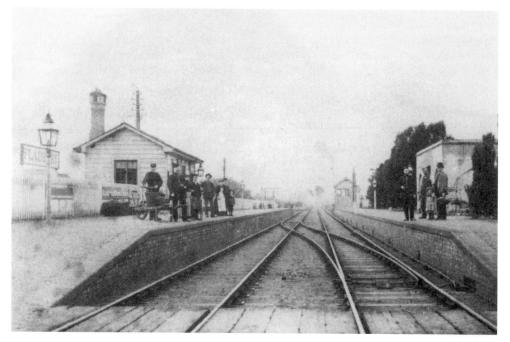

FLADBURY STATION on the Worcester to London Line of the GWR c.1900. Fladbury station was used by the local market gardeners to send their produce to London.

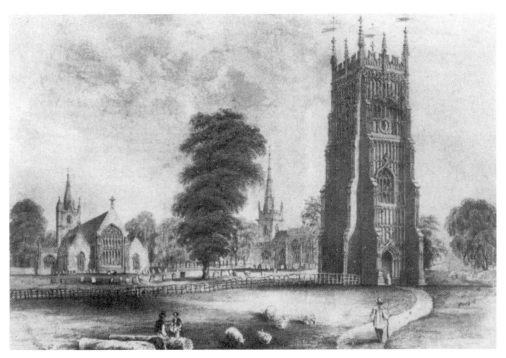

THE BELL TOWER AT EVESHAM. This is all that is left of Evesham Abbey, destroyed at the Dissolution of the Monasteries. The churches are All Saints and St Lawrence. The path through the tower leads to the River Avon.

THE LYGON ARMS, Broadway. A famous inn favoured by American tourists. Broadway became popular with Americans after the famous actress Mary Anderson married Ramond de Navarra. They lived at Court Farm and entertained many American visitors.

THE CHURCH AND VILLAGE GREEN, Cleeve Prior. 1970.

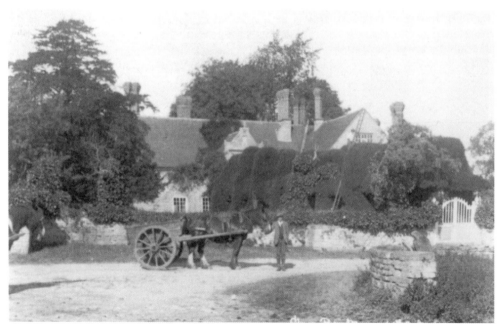

CLEEVE PRIOR MANOR. This sixteenth-century farmhouse was the home of the Lloyd family when I knew them. In the 1960s a cattle show was held there where Colin Creese and myself revived ancient games.

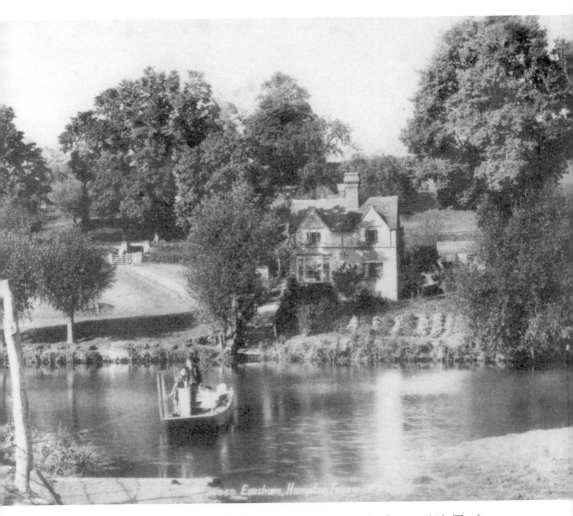

HAMPTON FERRY BOAT crossing the Avon from Hampton to Evesham *c*.1912. The ferry was the only way for the Hampton folk to get to Evesham without going the long way round along Bridge Street. In 1924 a new bridge was built, known as the Abbey Bridge, between Hampton and Evesham.

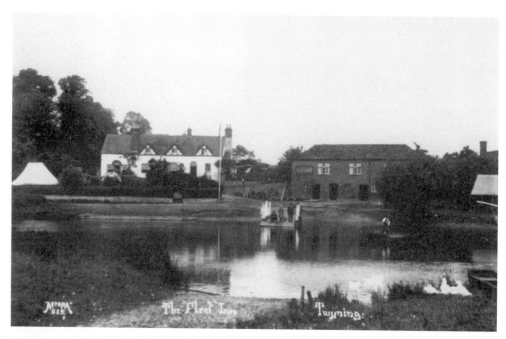

TWYNING FERRY. This shows a larger boat crossing the river, which would carry horses, cattle and wagons, but it was washed away in a flood.

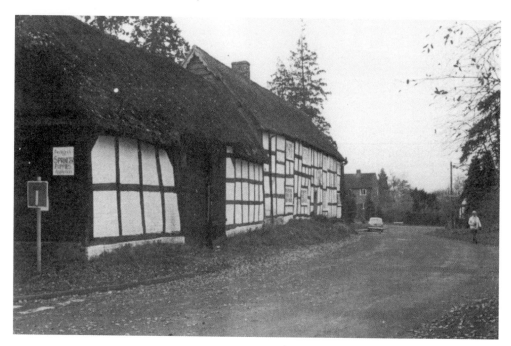

WICK NEAR PERSHORE seen in a black and white photograph taken *c*.1950. There is an old saying about Wick: 'It takes a man of Wick to walk over Pershore Bridge', wick being dialect for week.

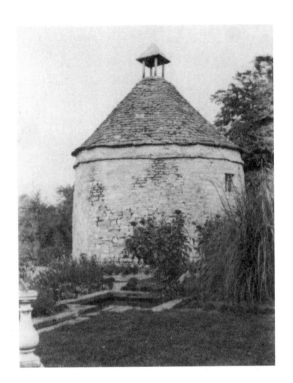

WICKHAMFORD DOVECOT. These dovecots always belonged to the Manor. Tenant farmers were not allowed a dovecot, yet the doves and pigeons which were kept for eating and shoots, used to feed from the tenant farmer's corn fields. Wickhamford Manor has connections with George Washington.

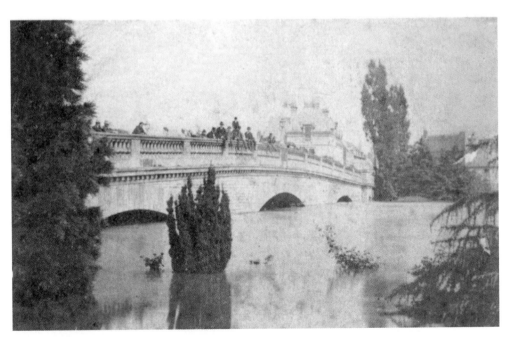

THE WORKMAN BRIDGE at Evesham with the River Avon in flood, 1875.

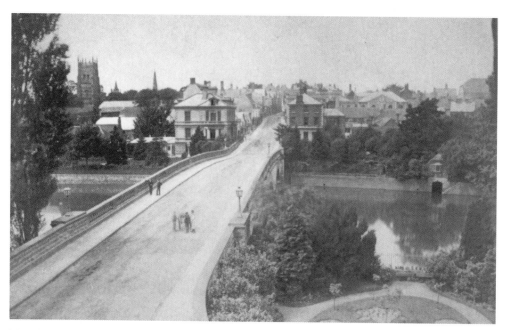

THE WORKMAN BRIDGE, Evesham, *c*.1880, This bridge was built and named after a former Mayor of the town, Mr Henry Workman, who also laid out the pleasure gardens known as The Workman Garden. The bridge separates Evesham from Bengeworth, which used to be called Donnybrook. The Bengeworth folk were extremely insular and would challenge and fight Evesham people on the bridge.

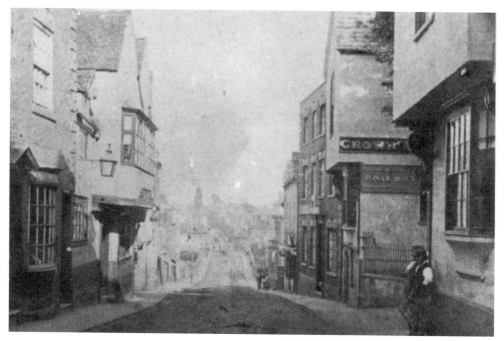

LOOKING ALONG BRIDGE STREET past the Crown Hotel towards the bridge and river. 1865.

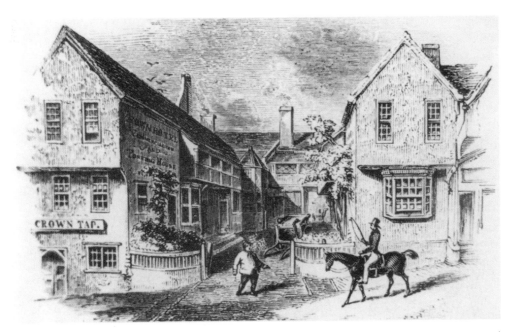

CROWN INN, Evesham, 1845. The Crown Inn was the principal coaching inn in the town and is now an office block.

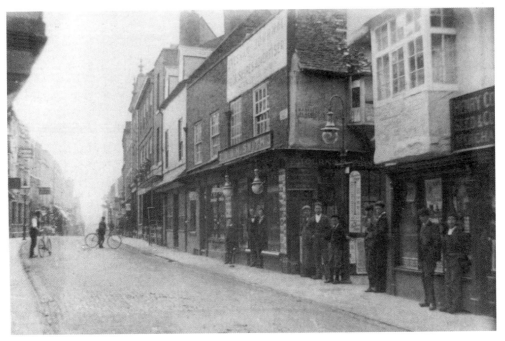

THE UPPER PART OF BRIDGE STREET, Evesham. The Journal office, which was W. and H. Smith's paper, is now the site of W. H. Smith's stationery shop. 1890.

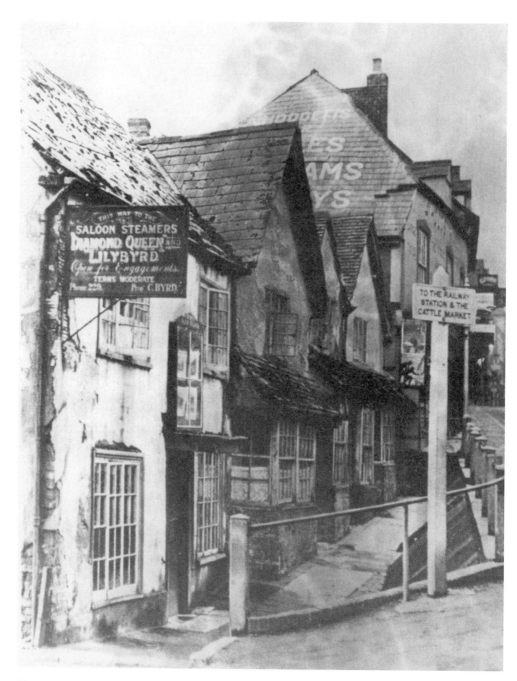

THE LOWER PART OF BRIDGE STREET with Fleece Cottages, which were demolished to make a road into the Abbey Park and riverside. One of the ancient buildings was occupied by Fanny Mace who sold fishing tackle and bait and mended umbrellas.

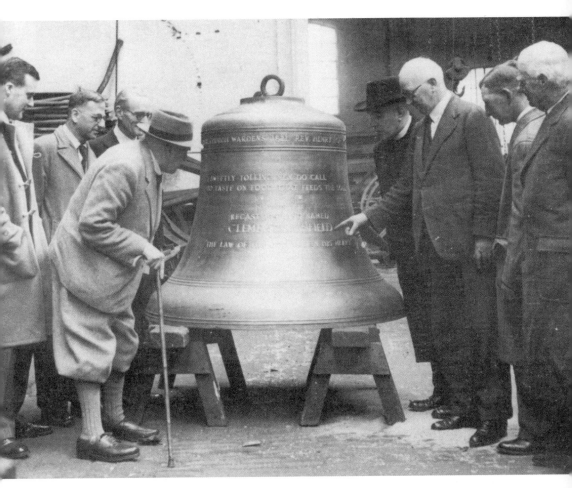

THE RE-CAST CLEMENT LITCHFIELD BELL with, from the left, Mr Burlingham, Tom Cox, Gill Smith, the Vicar, Mr Andrews and Fred Masters.

THE OLD METHODIST CHAPEL, Beckford, moved to Uckington. The Beckford Methodists included Mr and Mrs Adam Hawker and Mr Cloke from Beckford House, a very good farmer and local preacher. His subject one Sunday was that 'We are all Brothers'. One member said to him on the Monday 'You know what you said about us all being brothers. Would you lend me £40?' Mr Cloke was not brother enough for that!

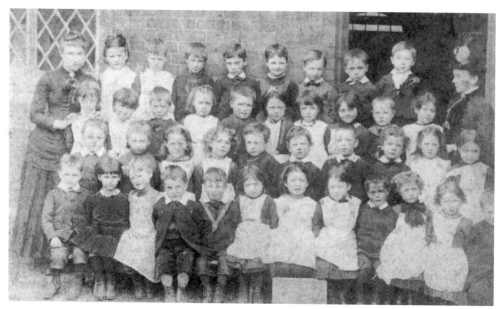

MERSTOE GREEN SCHOOL, Evesham, *c*.1910. The school is now a block of flats.

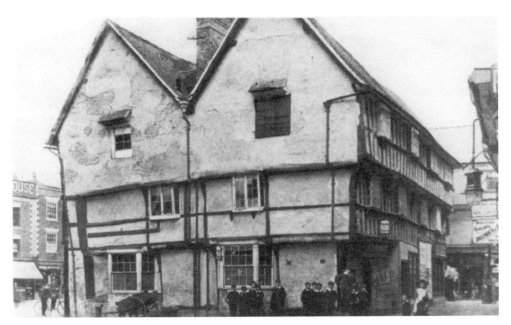

THE BOOTH HALL, sometimes called The Round House, pre-1914. The Booth Hall has now had its beams exposed and houses the National Westminster Bank.

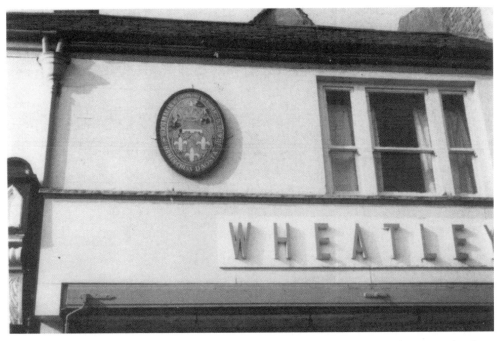

THE PLAQUE OVER MR WHEATLEY'S SHOE SHOP in High Street. It reads, 'Bootmaker by appointment to The Duke of Orleans.' It appears that Arthur Wheatley, the bootmaker, had the Duke's Coat of Arms on the plaque, or was it the *fleur-de-lis*? Arthur's son was christened Handel and he and his father were great violinists.

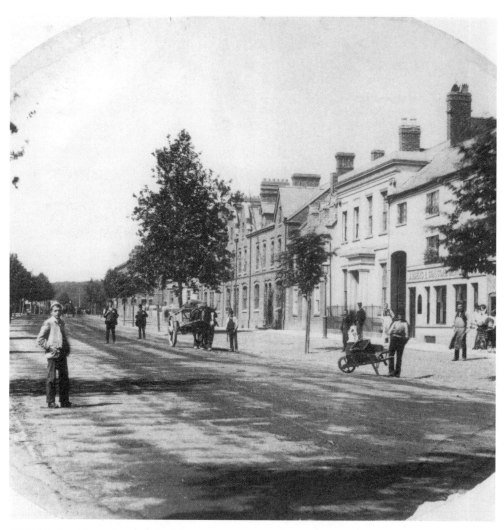

HIGH STREET, EVESHAM, looking north in 1900. The street has not changed. Mr Idien's coal-merchant's office is still as the photograph shows but is now Wallis White & Co. The house next door was, until recently, the doctor's surgery. The man with the wheelbarrow has an Evesham pot hamper and is probably going to market.

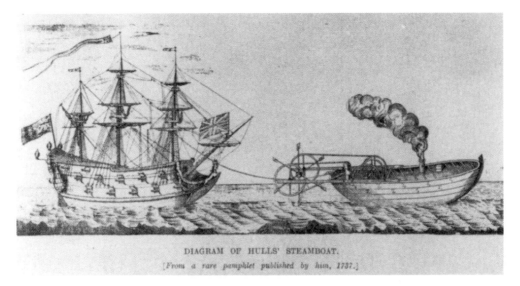

DIAGRAM OF THE STEAMBOAT INVENTED BY JONATHON HULLS and first used on the River Avon at Evesham. Hulls was the pioneer of primitive steam navigation and is reputed to be the first to successfully manufacture and sail a steamship.

THE BEE, the last steam barge to ply between Evesham and Gloucester, 1875.

EEL-FISHING WITH A SPEAR on the Avon at Evesham, 1920. This method of spearing eels was not so common as the eel traps fishermen set by the weir. The jellied eels were sold to tourists at Shakespeare's Rest in Cowl Lane.

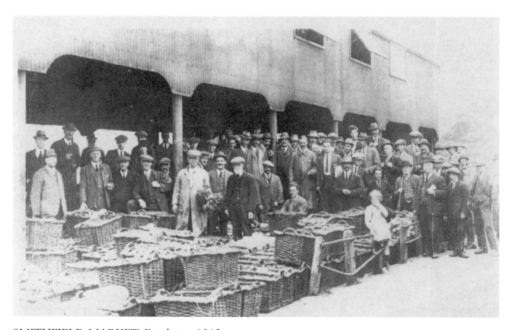

SMITHFIELD MARKET, Evesham. 1912.

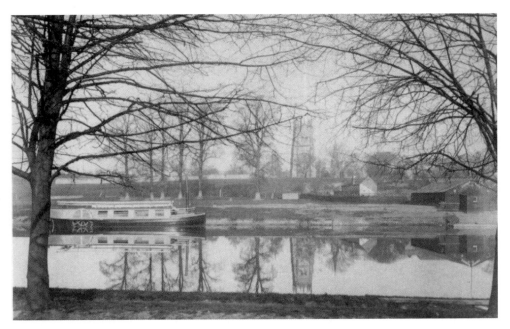

PADDLE-STEAMER ON THE AVON, 1885. Sam Grove's steamers, the Lillybird and the Jubilee Queen, used to ply the Avon. This steamer is earlier than those two.

MRS SLATTER, PRINCIPAL, AND MISS SLATTER, TEACHER, at Slatter's Preparatory School, Winchcombe, 1923. Norah Russell is on the left of the picture in the front row. Her father farmed Tythe Farm at Gretton and was a well-known breeder of Shorthorn cattle. On his death Norah farmed there until the farm was sold in 1936.

COTTAGES AT ASTON SOMERVILLE on the estate of Sir William and Lady Norah Fitzherbert. Old folk I know called the village Somervilles Aston.

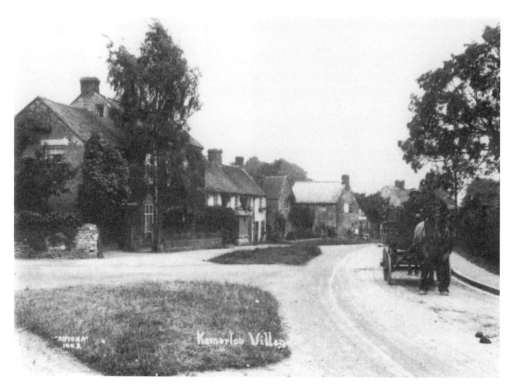

KEMERTON VILLAGE with its little village green and the Crown Inn behind the smaller green.

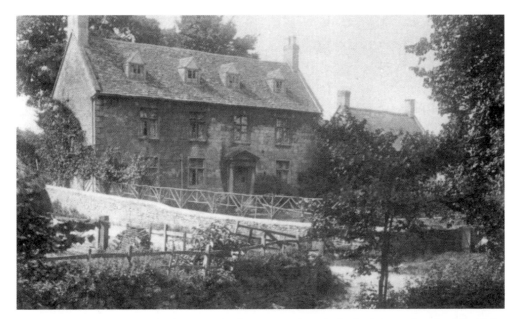

TYTHE FARM. Gretton. The front was built in 1700, though the back is much older. The Tythe Barn used to stand in the rickyard. The rickyard has now been demolished and new houses built on the site.

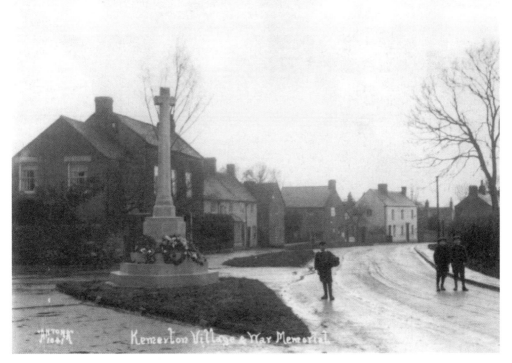

KEMERTON VILLAGE GREEN, now occupied by a war memorial.

A VIEW OF THE CHESTNUT TREE IN GRETTON. Norah Russell, aged 7, is standing in the road. 1919.

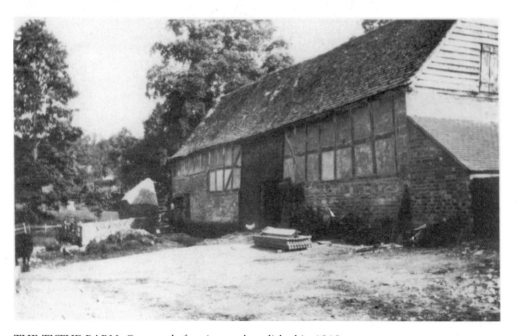

THE TYTHE BARN, Gretton, before it was demolished in 1919.